THE ISLEÑOS
OF LOUISIANA

THE ISLEÑOS OF LOUISIANA

ON THE WATER'S EDGE

SAMANTHA PEREZ

THE
History
PRESS

Published by The History Press
Charleston, SC 29403
www.historypress.net

Cover images: Map courtesy of the Louisiana State Museum. Back cover image courtesy of Dorothy Benge.

All images are courtesy of the author unless otherwise noted.

First published 2011
Second printing 2013

Manufactured in the United States

ISBN 978.1.60949.024.9

Library of Congress CIP data applied for.

For the Isleños.

CONTENTS

ACKNOWLEDGEMENTS

When my fiancé Joshua Robin and I first started the documentary project "Louisiana's Lost Treasure: The Isleños," which sparked the creation of this book, the Isleños were still a relatively unknown people. Gilbert Din's monumental book *The Canary Islanders of Louisiana* was already twenty years old, and only smatterings of academic theses and dissertations touched on their culture and history. Today, the Isleños are slowly making their way back into regional focus and into academic historiography through recent dissertations, newspaper articles and new publications. I'm so grateful to be part of this process, and I want to thank everyone who is working to preserve Isleño history and culture in this post-Katrina world.

I want to thank the many, many people who helped me get the original project and this book off the ground. I owe so much to the men and women whose stories are told here in this book through interviews. Thank you for taking the time to let me get to know you and your experiences and to share your story. Eternal gratitude goes to the Los Isleños cultural societies and especially to Bill Hyland, Bert Esteves, Rose Marie Powell and Dorothy Benge, the angel of the Isleños. Without your never-ending dedication, none of the current work on the Canary Island descendants would be possible. I also want to thank Dr. Bill Robison and Dr. Karen Fontenot for their constant support, encouragement and guidance. You two are the reason that any of this happened, and I owe you both so very much.

Lastly, I want to thank my parents, who brought me up understanding the Isleños before I even knew the word to describe them; my friends, especially Kelsy for being my soul-sister and proofreader; and Joshua, for your patience, for waking up early to take pictures at sunrise, for only grumbling a little when I asked you to fix the world and for helping me through this book every step of the way. I thank you, I love you and I can't wait to marry you.

INTRODUCTION
WHO ARE THE ISLEÑOS?

In 1778, two years after a band of thirteen colonies issued its Declaration of Independence, Paris recognized the United States as a republic. That same year, Benedict Arnold swore an oath of allegiance to the United States, Captain James Cook became the first European to land on the Hawaiian Islands and philosopher Jean-Jacques Rousseau died in France. Marie Antoinette gave birth to a baby girl in December, and a solar eclipse occurred over parts of North America in June. And in July 1778, amidst the uncertainty of a changing world, the *Santisimo Sacramento* left the Canary Islands off the coast of western Africa and braved the storms and perils of the sea to deliver the first wave of the Isleños to the humidity and heat of southeast Louisiana.

For a place known best for its French legacy—beignets, Bourbon Street and the Vieux Carré—it is difficult to imagine Louisiana with an undeniable Spanish past, but for a short time in the late 1700s, after a somewhat secret deal with the French, parts of the Louisiana territory fell under Spanish control. Seeing the opportunity to bring a Spanish presence to the French-populated area and to protect the huge amount of land from other countries' exploiting interests, the new government in Louisiana enticed inhabitants of their colony in the Canary Islands to journey to Louisiana. Plagued by drought and locusts, and promised money and support, the Canary Islanders agreed. From 1778 to 1783, thousands of Canary Islanders—now called *Isleños*, islanders—left their home off the coast of Africa and trekked to the foreign marshes of this near-forsaken corner of the New World.

At the end of the eighteenth century, New Orleans was already becoming one of the largest, busiest ports on the continent, but the marshes beyond the city were still untamed and wild. There the Isleños faced problems they never imagined in their island home. Mosquitoes brought strange diseases, and snakes, weather and the swamp ensured other dangers, including dreaded floods. Many had reservations, and many had fears, but the allure of the New World gripped them with the hope for a better life, just as it had for the French before them, the English in the thirteen colonies, the Germans in the North and anyone who took the chance for prosperity across the sea. The first ship of families arrived in 1778. Seven more ships soon followed. Directed by the Spanish government, the Isleños established four main settlements in strategic areas around New Orleans—Galveztown near Bayou Manchac, Barataria on the West Bank, Valenzuela in Bayou Lafourche and San Bernardo (now St. Bernard).

Since then, the Isleños have become silently more involved in creating the world we know today. They participated in the famous Battle of New Orleans in the War of 1812. They worked to make Higgins boats during World War II, and they have contributed to Louisiana's tourism industry, cuisine and identity for more than two hundred years. Now they struggle to save our coastlines after the *Deepwater Horizon* oil spill in 2010. In crisis after crisis, the Isleños across southeast Louisiana continue to prove what the original immigrants exemplified best: their ability to adapt and persevere. They adapted from the beaches and mountains of the Canary Islands to the swampy marsh of Louisiana, and they learned to farm, fish and trap and use the area's natural resources to their advantage. They adapted to the new world that Hurricane Katrina washed upon their shores in 2005 and have maintained a sense of tradition and custom for more than two centuries of change.

Not every story is a success, however. Settlements such as Barataria and Galveztown failed over time, and as southeast Louisiana opened up to the modern world, many parts of their customs have been lost. Overshadowed by the Cajuns, Creoles and French, the long-isolated Isleños and their unique culture have been largely ignored by textbooks and southern historians, threatening efforts to document their existence. Their isolationist tendencies make it difficult for their culture to spread past their traditional areas, and with every hurricane hit and every family that moves away to higher ground, parts of their culture fade into memory. As a result, the Isleños have become single paragraphs in Louisiana history books, a lone Spanish word on a tourism sign and, too often, an enigma in their own state.

Who Are the Isleños?

Although they arrived as farmers, the Isleños have been intrinsically tied to the water that dominates the majority of southeast Louisiana—lakes, canals, the river and the Gulf, as well as the storms that brew, have dictated and defined the lives and fortunes of the Isleños since their arrival. Many have thrived as farmers in a fertile land, trappers, fishermen and shrimpers. To this day, others make their livings producing nets for the industry, managing seafood restaurants and working on oyster boats. Before Katrina, generations of Isleño residents in St. Bernard Parish owned fishing camps in the canals near Lake Borgne, where they spent time together out on the water to fish, swim, trawl and just breathe. Maybe because they cannot escape it, the water has become permanently engrained as part of their identity, but each wave is also their greatest vice. All four of the original settlements endured floods before levees were built and suffered drowned crops. Settlers were forced to restart their lives almost seasonally. For this reason, Galveztown and Barataria failed. And with the storms of the twenty-first century still on people's minds, many Isleños are left wondering, "Who will be next?"

With all of the recent devastations, their question might have an answer too soon. Hurricanes serve as periodic reboots on life, but their growing intensity and frequency have many residents rattled. Thousands of families in the coastal areas have moved away to other parishes and even other states after reading the storms' writing on the wall. Hurricane Betsy served as a grim warning for the disasters in 2005. Homes, businesses and schools were completely washed away, and houses were swept off their foundations and moved across streets. Jobs vanished. People fled. With the focus on the city, most people in the adjacent areas had to struggle to provide for themselves. Many of those who have returned to rebuild have not fully recovered, and many never will. Worse, the erosion of the marshlands threatens the Gulf Coast area, allowing new storms to make landfall stronger and more violent than ever before because they did not pass over the vast amounts of marsh that once existed. Most recently, the *Deepwater Horizon* oil spill threatens the means by which the Isleños survive. Globs of oil have already bruised the seafood industry, and their life on the water is on the verge of being lost.

Today the Isleños survive in pockets of southeast Louisiana, including the Baton Rouge and Donaldsonville areas, Bayou Lafourche and St. Bernard Parish, southeast and downriver of New Orleans. Here they fight the battle of the everyman—to work, to provide for their families and to ensure that every next generation has better opportunity and a better world in which to live. But for many modern Isleños, work is not a nine-to-five desk job; it is the

grueling *pull-pull-pull* on a trawling line or the *heave* to move an oyster dredge. For many Isleños, family is not a nuclear unit with distant relatives; it is the hundreds of cousins, aunts and uncles living in the same town, a town where everyone knows your name, your dad's name, where he went to high school and how you are related to a mutual cousin somewhere down the line. For St. Bernard, it is a town affectionately divided into up-the-road and down-the-road, and everyone knows what that means.

The better world they hope for is one of full stomachs, laughter, barbecue, bare feet on a burning wooden wharf, the closeness of family, the buzz of a flying cast net and, always, happiness. Every action in their daily lives is an unconscious fight to preserve their traditions in an ever-changing world. Organizations such as the Los Isleños Heritage and Cultural Society and the Canary Islanders Heritage Society remind the community of their Isleño roots and keep key aspects of their culture alive. Through their efforts, the arts of singing *décimas* and making intricate Tenerife lace earrings survive. Carefully, the Isleños balance the merits of Americanization and the active effort of fathers and mothers, uncles and aunts, to pass on their ways so that children can gain a sense of how they live and how they have always lived.

Despite the popularity of Louisiana history, little academic research focuses on the Isleños. Several master's theses and PhD dissertations cover aspects of their culture and past, but most deal with their unique dialect of the Spanish language or a particular phase of their long history, especially the political reign of Plaquemines Parish political boss Leander Perez. Only a handful of books involve exclusively the Isleños, and one of the most comprehensive of these is *Canary Islanders of Louisiana* by Gilbert Din, published in the 1980s. So much has changed since then, and so much has been lost.

For its part in the struggle to hinder the effects of time, this book retells Isleño history and captures the personal stories of the Isleños, past and present. Through research and interviews, this is their story—or at least part of it. This is not a history of the past, of dead things and lost clay shards or arrowheads in the dirt. The main contention of this book is that Isleño history is a living history that continues to build and grow from the first seeds the Isleños planted to the great ships they helped build in World War II. This is their modern condition. Because St. Bernard is the most culturally intact of the original settlements, much of the book deals with them, but the Isleños are everywhere in Louisiana and the South. They endure.

Over the years, St. Bernard Parish has proved to be the most cohesive Isleño community because of its isolated location. Until the 1970s, land

access to parts of the parish was limited, helping the Isleños-dominated community preserve its unity up to the twentieth century. In fact, not too far into the region, there used to be a sign: "The end of the world." The accuracy is chilling. The mouth of the Mississippi opens up and flows into the Gulf. Towns shrink. Roads end. Because of its isolation, St. Bernard remains one of the last major concentrations of the Isleños in Louisiana, and their location has helped preserve their culture for generations. Some residents still speak the Isleño dialect of the Spanish language; others wear the traditional Isleño dress at special occasions; and every March, the parish comes together to celebrate their heritage at the Los Isleños Fiesta. Whether they are aware or not, the Isleño identity of the area continues to shape their future.

The history of the St. Bernard Isleños is a continuous story of disaster and recovery. Countless floods swamped the area before the levees were built; broken promises, internal fighting and, sometimes, unfair politics impeded progress. And nature itself has reset the clock more than once. From the Flood of 1927 to Hurricane Betsy in 1965 to the powerhouse Katrina in 2005, the parish has been destroyed, submerged and raised back up by the tireless hands of the resilient Isleños and the other equally proud residents. Caught in this cursed and endless lather-rinse-repeat cycle, the Isleños understand to value their homes, their possessions, their world and their life as they know it. As a people so resistant to change, they continue to return to a community and a way of life tried and tested by the generation before, even as bits of their culture begin to wash away.

It is not hard for the residents of St. Bernard Parish to realize how evanescent things are in southeast Louisiana. Nature reminds them every time they look at the marsh and the encroaching waters along Paris Road, which snakes out of the parish toward New Orleans. The epitome of everything ephemeral, everything fleeting, is right there, just beneath the surface of the water, beneath the roots of that marsh.

That used to be the road.

CHAPTER 1
A BRAVE NEW WORLD
THE JOURNEY TO LOUISIANA AND THE EARLY SETTLEMENTS

Very few experiences are as dangerous to a people's survival as the passage from isolation to membership in the world-wide community that includes European sailors, soldiers, and settlers.
—Alfred W. Crosby, "An Ecohistory of the Canary Islands: A Precursor of European Colonization in the New World and Australasia"

The photographs and framed posters of Gran Canaria on the wall sport images of the island's perfect beaches and the cool shade of a palm tree as I walk into the house of my first interview. It looks like paradise—the sunlit sand, the blue, diamond-studded waves—but this is the world of 2010. In the late 1700s, when the residents of Gran Canaria and the rest of the Canary Islands began to discuss leaving this heaven for Louisiana, it was not heaven at all—but then neither was the New World.

"The pictures are gorgeous," I remark as I sit down in the living room.

Dorothy Benge, the current president of the Los Isleños Heritage and Cultural Society, smiles in response. She is dressed in her traditional Canary Island garb for the occasion—a bright red- and yellow-striped skirt and a crisp, white blouse. Tenerife lace earrings dangle beside her face.

"I'm doing a project on the Isleños in southeast Louisiana," I explain. "I'd like to tell their story."

"Well," Benge begins, "the Isleños are descendants of the settlers who came to Louisiana beginning in 1778 from the Canary Islands. They came at the request of Bernardo de Galvez, the fourth Spanish governor of Louisiana. He communicated to the king that he needed help here. He needed people to settle if they were going to keep Louisiana."

And people came. From 1778 to 1783, two thousand Canary Islanders journeyed to Louisiana and settled as soldier-farmers in four main settlements around the Isle of Orleans. But the world they came to was radically different from the beaches and mountains of the Canary Islands. Here, in the swamps and marshes, mosquitoes swarmed, alligators lurked and the Isleño settlers faced storms and disease.

"These people are so adaptable," Benge insists. "I mean, they came from the Canary Islands, which are mountainous outcroppings in the Atlantic Ocean. They don't have hurricanes. They don't have snakes. They don't have roaches. They don't have the bugs that we have. And they came here to this flat, swampy, marshy ground, and they carved a living for themselves." She smiles again. "That's what I say about being proud of how adaptable they are. And they *still* are, especially after Katrina."

Looking around the room, I realize that Isleño artifacts and memorabilia decorate every shelf and mantel. Little plastic Canary Island flags lean against Isleño-dressed dolls that are thrown at the annual Irish, Italian, Isleños Parade. Maps of the islands hang on the walls. The room is a testimony to the effort to preserve the history of the Isleños in the face of current hardships and setbacks. Dorothy Benge herself is a living example who proves that history continues to be made by the Isleños, who remain in the bayous and marshes across southeast Louisiana. Many of them still live in the areas where their ancestors first arrived, settled and farmed more than two centuries ago. Their story is a living history.

"A lot of them stayed," Benge says of the Canary Island descendants in Louisiana. "A lot of them foolishly stayed during Katrina—but they came back. As far as the Isleños are concerned, there's no place like St. Bernard." She grins. "Except maybe the Canary Islands!"

Just like Dorothy Benge says, Isleño history is still going, thriving and adapting, but to properly understand the Isleños, their culture and their history, people have to understand the source—the Canary Islands.

Just one hundred miles or so off the coast of Africa, the string of seven major Canary Islands flitted in and out of the European West's recognition for centuries before the Age of Exploration. At some uncertain point, a group of people now called the Guanches came to the islands and began to inhabit the area in pastoral-oriented tribes. There they raised flocks of goats, farmed their fertile land and carved simple, peaceful lives out of the volcanic rock around them. Historians continue to debate the origins of the Guanches,

whether they descended from the ancient Minoans or the Cro-Magnons or even, as some have boldly suggested, whether they came to the Canary Islands from the remains of nearby Atlantis.

Somewhat recently, researchers have turned to the marvels of modern science to solve the mysteries of history, such as the origins of the Guanches. In 1966, a team of English scientists took blood samples of men and women on Gran Canaria to deduce through genetic analysis who the Guanches really were and from where they really came. Prior research completed by men such as John Abercromby, Earnest Albert Hooton and Rene Verneau had relied mostly on the measurements and shaping of skulls and mummy remains, as well as speculations about language similarities. In their article "Blood Groups and the Affinities of the Canary Islanders," D.F. Roberts, M. Evans, E.W. Ikin and A.E. Mourant stated that various antigens in the blood samples suggest strong western European influence with minor African ties. They conclude that a northwest European component dominates the current Canary Island gene pool at 75.1 percent and features fewer contributions from north and west Africa. Interestingly, there is only a slight Iberian influence. "This result," they remarked, "is surprising in the slightness of the Spanish contribution it indicates. It suggests that the original Spanish conquerors, though dominant socially and culturally, may have contributed very little biologically."[1] Having confirmed that the Guanches' blood properties are still, in fact, intact, the scientists point out the similarities between the genetic qualities of the Canary Islanders and those of the Scots, Irish and Icelanders, hypothesizing a link between the ancient Guanches and the populations of the northwest European periphery somewhere, sometime in the past.

Roberts and company's research and others like it helped to open further doors and uncover deeper links between history and science. In 2001, geneticist Bryan Sykes published *The Seven Daughters of Eve*, a DNA analysis of the origins and spread of mitochondria in Europe. Using those methods as his basis, he later traced the roots of the British Isles in *Saxons, Vikings and Celts* and discovered the genetic makeup of the early inhabitants of Britain and Ireland. With any luck, researchers can one day employ science to unveil similar breakthroughs about the Guanches.

Regardless of their origins, the islanders and their home appeared in various documents during the Roman era, earned their name from the Latin word *canis* for dog and then were promptly forgotten by most of western Europe after the collapse of the empire. Arab traders continued to visit the Canary Islands throughout the Middle Ages and used them as conveniently

located trading outposts, but for the most part, the Guanches were left alone by the world beyond.

Toward the end of the medieval period, at the beginning of the fourteenth century, western Europeans began to more actively explore the sea surrounding them and hunt down naval trade routes to the East, and soon they rediscovered the Canary Islands and their usefulness. In the early 1300s, an explorer from Genoa named Lancelotto Malocello landed on the northernmost island, which now bears his name, and settled there for a couple of decades before getting killed by the Guanches.[2] By the very beginning of the 1400s, French expeditions had conquered Lanzarote, Fuerteventura, Hierro and, soon after, Gomera. Lands were seized, Guanches were enslaved and new diseases roamed the once isolated islands until, by the middle of the fifteenth century, only three major Guanche strongholds remained—La Palma, Tenerife and Gran Canaria.

In his article "An Ecohistory of the Canary Islands," Alfred Crosby detailed the conquest of these islands and the people who lived there. In 1478, he wrote, Ferdinand and Isabella—the rulers of a newly united Spain who would later serve as bankers to Christopher Columbus—commissioned

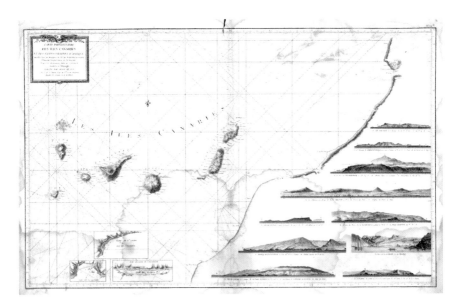

The seven major Canary Islands, once inhabited by the Guanches, captured the eye of Europe in the late Middle Ages and into the Age of Exploration. *Courtesy of the Louisiana State Museum.*

an expedition to Gran Canaria composed of "hundreds of soldiers with cannon, horses, and all the paraphernalia of European warfare. The campaign for the island lasted five bloody years."[3] The Guanches resorted to guerilla tactics and even a desperately formed alliance with Portugal, which was trying to block Spain's bid for the islands. Despite their efforts, "six hundred Guanche men, 1500 women and a number of children, besieged in the highlands, surrendered to the conquistador of Gran Canaria, Pedro de Vera" in April 1483.[4] The residents of La Palma, having already watched five of their sister islands fall, submitted themselves to the wave of Christian converters and Spanish conquerors that had crashed violently upon their shore. Only Tenerife, the largest of the seven, full of what Crosby called "numerous and bellicose" defenders, remained free.[5]

Although Gran Canaria had been no easy victory, the Guanches on Tenerife successfully repelled the European invaders for the better half of a century. They fought Europeans in the 1460s and again in 1490; in 1494, they defeated Alonso de Lugo in the massacre of Contejo. The Guanches survived by playing to their strengths and knowing their terrain. They did not have swords; they did not have bows. Instead, the Guanches of Tenerife nearly defeated the invading Spanish with literally sticks and stones. They stuck to the high ground they knew and leapt over ravines and rocks with agility and familiarity that the Europeans lacked. They could break apart shields with stones just by the force of their throw. They did not have horses; they did not have guns. They had sticks and stones. From what we know of the Guanches on Gomera, they had a whistle language that carried across miles, across canyons, across the great din of battle. They were brave in the face of the unknown, they were tough and they were fierce, but they were disunited and lacked necessary modern advancements. The Spanish turned the Guanche tribes, already separated by language and geography, against one another. Slave ships raided the coast. The Guanches' morale plummeted when they realized the seeming endlessness of Spanish resources. As a result, the Guanches of Tenerife surrendered to the relentless Spanish forces, still led by Lugo, in September 1496.

Defeat was far from the end of the Guanches' trials. Many were forced into slavery; tribe rulers and kings were whisked away to the mainland to serve as souvenirs of a job well done. Mysterious diseases, recorded as *peste* and *modorra*, hit hard at the end of the 1400s, greatly facilitating Spanish takeover of Gran Canaria and Tenerife.[6] Europeans moved in and changed the landscape to suit their needs. The islands would, after all, soon serve as

beneficial last stops for ships crossing the Atlantic or traveling along trade routes around Africa to reach the East. With their universe irreparably changed, the Guanches had become, as Crosby noted, "a paltry few, stumbling along the edge of doom, numbly observing their own extinction."[7] The Spanish ripped down their forests and introduced horses, cattle, rabbits and sugar. They intermarried with the natives and quickly shut down any hint of rebellion until the Guanches simply ceased trying. At the close of his article, Crosby lamented: "The Guanches declined even faster than the forests, and their replacements spread faster than the weeds."[8] Although remnants of the Guanches still exist in the Canary Islands—in the build of a man passing down the street, in the caves and in the museums—their day in history was drawing to a close. A new dawn was rising in Europe.

In 1492, Columbus sailed the ocean blue, bumped into a massive rock in the middle of the Atlantic Ocean and launched the beginnings of a new crusade across the sea.

The race to the New World was on.

By the seventeenth century, now armed with better ships, better tools for nautical navigation and the exploding desire to explore and expand, Europe turned its lidless eyes to the Americas. In 1607, English adventurers formed their first colony at Jamestown, Virginia. It nearly failed. The French settled in Nova Scotia and the vast Louisiana Territory. Like Portugal, Spain went south in search of gold and other fortune. Regardless of where the explorers ended up in the New World, the Canary Islands remained crucial to the journey. In the hundred years since their conquest, the islands had become bustling trading centers where ships could restock, get supplies for the colonies and pick up any extra sailors they might need.

Spain still had custody of the islands, although this was not for lack of trying on the part of other nations. Even in the early years of Spain's presence on the Canary Islands, other European powers had already started to notice their worth as gateways to the New World. Neighbor Portugal had contested Spanish control of the islands almost as soon as Spanish efforts of conquering began, but when Spain defeated Portugal in the War of Castilian Succession in 1479, the Treaty of Alcáçovas that emerged determined the islands under Spain's growing arm. England, with its impressive naval strength, also tried to take the Canary Islands. In 1595, Sir Francis Drake himself attempted to capture La Palma. In the mid-1650s, Robert Blake attacked Santa Cruz de Tenerife with a fleet of thirty-six ships and devastated nearby Spanish vessels

and much of the port.[9] Then, again in the 1740s, the islands were dragged into a new fray between Spain and Great Britain called the War of Jenkins' Ear, an economic clash over trade rights that left one British ship captain missing an ear. Battles in the area wreaked havoc on ports, lives and local economies. All in all, the pattern of European bickering followed them to the Canary Islands and then to the Americas. Even though now the game board was larger and more global, the same conflicts dogged them across the sea.

It was in this spirit that in 1756 Europe fell gracelessly into the bloody and brutal Seven Years' War. Several countries, grieved over the outcome of the recent War of Austrian Succession (of which the War of Jenkins' Ear had been a phase), desired to check Prussia's efforts to expand and reclaim lands lost to them in the Treaty of Aix-la-Chapelle only a few years before. Various alliances forced almost all of Europe into what is now recognized as a true world war. The conflict reached the Americas, west Africa and all the way to India; Great Britain, Prussia and several smaller states fought France, Austria, Spain, Russia and Sweden at every turn across the map. However, in 1762, when France lost the Battle of Signal Hill, the country sensed the impending British victory. Hoping to keep the Louisiana Territory out of British hands, King Louis XV of France passed the entire space of land west of the Mississippi River, as well as New Orleans on the East Bank, to his cousin, Charles III, of Spain in the secret Treaty of Fontainebleau in late 1762. It was not a moment too soon. After seven long years, peace negotiations in Europe finally reached a successful close early that spring. The war was over.

To cement this hard-earned peace, Spain, France and Great Britain signed the Treaty of Paris in February 1763 and formally concluded the war. Peace with Prussia and the other involved nations followed only a few days later. As a result, France returned the British territories that it had conquered during the course of the war and forfeited Canada and the eastern portion of Louisiana, minus the port of New Orleans, to an eager Great Britain. Spain was forced to cede Florida, but the Treaty of Paris acknowledged the agreement made between France and Spain only a few weeks earlier. Britain, satisfied by the results of the complex land switching and compensations, accepted the Treaty of Paris and the new owners of the huge land that had once belonged to France.

With that, western Louisiana and the prize jewel, Isle of Orleans, came to Spain.

On August 15, 1777, the Spanish government issued the royal order to begin recruitment on the Canary Islands for the population and defense of Louisiana. Some of the local officials protested the edict, citing the potential problems of a sudden population decrease, but because of progressively dire circumstances on the islands, many residents accepted the opportunity that Spain offered. It was not the first time that Canary Islanders had agreed to immigrate to parts of New Spain. Earlier in the 1700s, before Spain had custody of the Louisiana territory, Canary Islanders had ventured to other Spanish colonies in North America and the Caribbean, including Texas, Cuba and Puerto Rico. Yet the increase in recruitment activity was certainly a change—and so were the intended settlement locations around the Isle of Orleans.

For various reasons, Spain was desperate to bring their presence to south Louisiana. Rising tensions between England and their uprising colonists only meant trouble for Spain, and Louisiana served as a necessary protective barrier between New Spain and the British in Manchac and Mobile. Even worse, the transition from French control to Spanish only a few years before had not been exactly peaceful. The tumultuous shift in authority had culminated in the Rebellion of 1768 when the Louisiana French overthrew the first Spanish governor, Antonio de Ulloa. As a result, Spain understood the need to bring soldiers to the area to maintain control, and it turned to the Canary Islands for manpower.

In November 1776, Minister of the Indies Joseph de Galvez wrote to the acting governor of Louisiana, his nephew Bernardo, and suggested stronger efforts to colonize Louisiana with men and women loyal to Spain and reminded him that Louisiana served a vital purpose: the protection of New Spain. He insisted that populating the territory with Spanish soldiers would deflect English efforts to take their land if war was declared. Less than a year later, the Crown had issued the royal order for recruitment in the Canary Islands.

It is almost impossible to imagine such a situation that would prompt these people to journey into the unknown with their families and children in tow, but many felt no other choice than to escape the troubled islands before it was too late. A plague of African locusts invaded the Canary Islands around the same time that Spain issued the decree to recruit the islands' inhabitants for Louisiana settlement. Paired with a terrible drought, the locusts ruined the dried-out crops on which the farming islanders were dependent.

"They had good reasons for leaving," Benge says. She sets her hands into her lap, and they get lost in the colors of her bright Isleño skirt. "One thing,

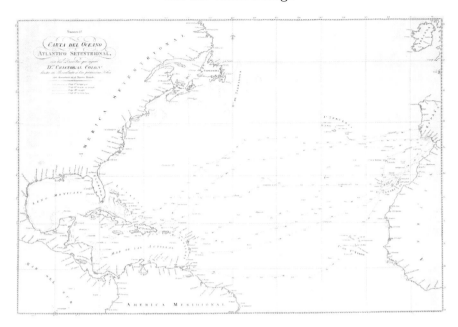

Map illustrating the naval routes taken from the Canary Islands to Louisiana. *Courtesy of the Louisiana State Museum.*

when we visit the Canary Islands, we say, 'Why would anyone want to leave here? It's so beautiful, it's so wonderful.' It wasn't so beautiful at that time. Sickness was widespread. They had a drought. They had the invasion of the African locusts. So, really, it was an opportunity to get out of a bad situation."

The attacks on their towns during the War of Jenkins' Ear were also still fresh on their minds, and they clearly remembered the economic turmoil each assault brought. With families to provide for and new opportunity to be seized, hundreds of Canary Islanders agreed to serve in the Spanish military force in Louisiana in exchange for money, support, land and a much-needed new start.

Lieutenant Colonel Andres Amat de Tortose from Tenerife handled most of the initial recruitment for men to serve in the Spanish military in Louisiana and for their families, as well. He carefully documented the information provided by the recruits from Tenerife, Gran Canaria, Gomera, Lanzarote and La Palma.[10] Some deserted when it came time to leave for Louisiana, but most gathered in Santa Cruz when the ships arrived in the harbor.

"They were given incentives to come," Benge adds to explain their willingness to make the journey. "They were given ninety *reales* per man. They received half in the islands, half when they got here."

On July 10, 1778, the first group of Canary Islanders boarded the *Santisimo Sacramento* in Santa Cruz de Tenerife. More than 260 passengers—men and women and children, all ages—walked onto the ship and left to cross the Atlantic. More ships soon followed. Three months after the *Santisimo Sacramento* left Santa Cruz, the three-masted *La Victoria* departed with its 88 recruits and their families to cross the Atlantic. That same month, the frigate *San Ignacio de Loyola* set sail. The *San Juan Nepomuceno* left with 202 passengers in December 1778. The *Santa Faz* left in February 1779 and arrived by July. Three other ships—the *El Sagrado Corazon de Jesus*, the *Nuestra Senora de la Dolores* and the *San Pedro*—also left the Canary Islands, but because of a new war with England involving a group of rather bold colonists, they were detoured to other parts of Spanish territories, including Cuba, Venezuela and abandoned parts of Florida.[11] After the war, some of the Canary Islanders finished the journey to Louisiana, but others were too adjusted in their new areas to leave.

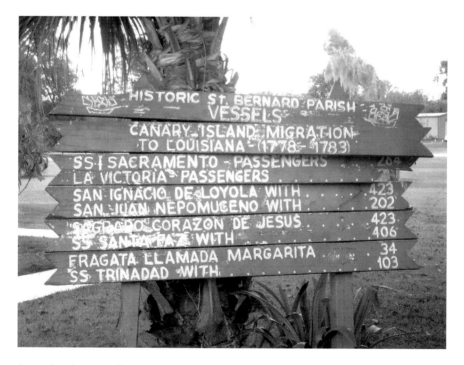

A wooden sign at the Los Isleños Museum lists the ship names and their passenger counts.

Ventura Perdomo y Quintana puts a face to the desperation that prompted families to move into the unknown. Ventura was part of the first wave of Canary Islanders to enlist for Louisiana aboard the *Santisimo Sacramento*. In July 1778, he left Santa Cruz de Tenerife with his wife, Maria Hernandez, and their eight-month-old daughter. Modern parents bring their babies to pediatrician checkups at that age in sanitized rooms to get vaccines for life; Ventura and Maria brought their daughter across the sea on a crowded ship full of farm animals, disease, rationed food and the constant threat of storms and sinking. As a family, they crossed the Atlantic with 261 other passengers. Gilbert Din wrote that the people on board "would receive two hot meals daily, consisting of meat or fish in the morning and pottage (menestra) in the evening. For the sick there was soup, and for the crying children biscuits."[12] The ninety *reales* that Ventura was promised for enlisting seems almost too small a price for the risk he took with his family.

Ventura and Maria must have had their worst fears realized when people on board the *Santisimo Sacramento* started to get sick during their voyage. Too late to turn back, there was no escape from disease on board the ship; 6 of the 125 male recruits died while crossing the ocean, and many more were too sick to go on.[13] Desperate, the captain made an unplanned stop in Havana to get the sick off the confines of his packet boat. They reached Cuba in September, and 14 recruits and their families stayed behind. Whether Ventura and Maria were with them then the records do not show. We do not know if they lived and made it to America, or if their baby girl died at sea. We do know that on November 1, 1778, All Saints' Day, the remaining recruits and their families on board the *Santisimo Sacramento* arrived in New Orleans to start their new lives.

GALVEZTOWN

The usual morning humidity is already starting to slip into afternoon heat by the time I pull to the side of the road and reach my next interview location just near Port Vincent, Louisiana, twenty-five miles from Baton Rouge. More than two hundred years ago, the Isleño village Galveztown once stood here. Today a dozen archaeology students from Louisiana State University are working in a flat, grassy field. Little red-orange flags that mark their grid poke out of the ground and wave in the blowing wind. On one side of the field, they huddle over troughs and sift through their dirt. Dr. Rob Mann,

their LSU professor and instructor on the dig site, looks over their shoulders as they continue to work. Even with their equipment and a tourism sign that promises that this was the site of Galveztown, it is difficult to imagine that where I am walking is where a whole village once stood.

Although English colonists were already living in the area by the time Spain took control of Louisiana, Galveztown was formally established in 1778 when those Anglo-Americans decided to name their town Villa de Galvez after Bernardo de Galvez.[14] Galvez, of course, accepted the honor and gave each of the English settlers Spanish names. He personally selected the site of Galveztown for the incoming Canary Islanders because it would serve as a barrier between the heart of the Isle of Orleans and the British settlements in west Florida that had been controlled by England since French defeat in the Seven Years' War in 1763. Located where the Amite River meets Bayou Manchac, Galveztown brought the Canarian farmers face-to-face with the swampy water that dominated their new home. The establishment of this settlement was one of the first notable steps in the transition into Spanish Louisiana but ultimately was a disaster for the Isleño people who lived there.

With the students today is John Hickey, an active member of the Canary Islanders Heritage Society. Over years of dedicated study, Hickey has completed extensive genealogical research for local Isleño families.

"Why the Canary Islanders?" I ask him as we walk across the field. My foot sticks a little in the mud. "Why here?"

Hickey settles into a lawn chair someone left in the shade of one of the few trees there. "The Spanish government had been using the Canary Islands for a number of years as a source of manpower for its colonies in the New World. The Canary Islanders specifically were brought because at that period in the late 1700s, the Spanish government had some fears."

"Fears?" I ask.

"The turmoil of the American Revolution," he says. "For hundreds of years, the Spanish had had problems with the British over its possessions in the New World. So fearing the possible British invasion and the capture of New Orleans, they decided they wanted to increase the size of the military in Louisiana, so they requested the king to allow them to recruit. The king directed that the recruitment be done in the Canary Islands."

With the site already personally picked out by Galvez, the Spanish government directed the Isleños to Galveztown and three other areas in the New Orleans periphery by late 1778 and early 1779.

"Settlers started arriving in very late 1778," Hickey explains. "By early 1779, about April, there were about one thousand people who had collected in New Orleans from the ships that had arrived. At that time, they broke them into groups and put them at the settlements. Four hundred settlers were sent here to Galveztown."

Beginning in January, Canary Islanders began to arrive in Galveztown in small groups, usually about fifty people at a time, and moved into small wooden houses that had been constructed for them by Sub-lieutenant Francisco Collell and slaves under his command.[15]

"Because they couldn't get the bachelors they wanted, they decided to accept men with families with the idea that they would place the men with families in settlements around southern Louisiana, and that would help with the defense of New Orleans. The men would be part of militia companies, and the rest of the population would provide a Spanish presence where there was not one."

I think back to Ventura Perdomo y Quintana and his family. Did they come to Galveztown? Was he part of the Spanish militia company?

In the early years after the arrival of these men and women, prosperity tried to grow in the settlement. As the waters of the Amite River rose in the spring, Fabian Ramos, a corporal in the Spanish militia in Galveztown, asked Collell's permission to marry the seventeen-year-old Isleña Maria del Buen Suceso.[16] Collell approved the union, and more Spanish-Isleños marriages began to take place in the budding colony.

The reasons for celebration were unfortunately short-lived. A lack of necessary supplies stunted the settlement's growth, and various diseases, incubated and augmented by the Louisiana heat and humidity, took a heavy toll on the population. The threat of war against Britain escalated, as did the mortality rate. Rains and flooding in the 1780s destroyed crops, and food shortages coupled with lack of construction materials and the death of a priest sent waves of panic through the small community.

"There's no town here anymore," I say.

"These sites were selected for military purposes, not for habitability," Hickey reminds me. "In the first year, 161 of the settlers at Galveztown died."

"What was wrong with this area?" I ask.

"The Amite River just flooded too often, the storms just damaged too often and they just never got started, so to speak. They were always starting over. Every year, they were starting over."

Oddly, even after two hundred years, not much has changed.

After enduring a bombardment of natural disasters, including hurricanes, floods and outbreaks of smallpox, the colonists of Galveztown petitioned to the Spanish government in 1787 and 1788 and begged to relocate to other Isleño settlements, especially St. Bernard.

"Eventually, the Spanish government pulled support from the settlers at all of the sites, and they were pretty much left on their own," Hickey says.

Hurricane winds and waters knocked down Galveztown's houses and flooded crops, thrusting the Isleños back into poverty, desperation and dire straits. Many families, tired of constantly wringing out their lives, capitalized on the confusion caused by the changing ownership of the Louisiana Territory to escape Galveztown. They moved away to other areas, including Spanish Town outside Baton Rouge and St. Bernard. By the time America assumed control of the area, the Villa de Galvez was quickly becoming a ghost town. In the two centuries that have passed, their broken wooden houses have vanished into the soggy grass in the empty field that is there today.

"Why are people so interested in this site?" I ask.

"It was only occupied about thirty years," Hickey replies. "The only people that lived here were the few English and the few other people who were here and the Canary Islanders, and then everybody left. It was like a time capsule. It was used and nobody used it again. So if we find something here, we're pretty sure it came from the Canary Islanders or the people who were inter-mixed with them here."

A row of fishing camps and houses now lines the nearby lake, but the large fields remain open and ready for digging. LSU has sponsored several amateur archaeological digs at the Galveztown site, and so far students have unearthed remnants of brick, musket balls and coat buttons from the lost town. As interest in the project continues to grow, so does the hope that future research of the area will one day yield larger discoveries.

Hickey certainly shares this hope. "We know that there were about thirty- or forty-odd houses on this site in addition to the church and fort," he says, gesturing around the empty field. "We keep hoping that we will stumble on one of those houses. We will find the line of the house, and we will know that is where we want to dig in the future to expose the whole footprint of the house, and then see what happens from that point."

By the 1830s, most remnants of Galveztown had vanished. Its former residents had moved to other Isleño settlements or even to the nearby Spanish Town and Donaldsonville areas. Roads gave way to nature and disrepair. People moved on.

VALENZUELA

Upriver from New Orleans, near the beauty of Bayou Lafourche, Galvez selected another settlement location, this time for a village called Valenzuela. By the beginning of 1779, Canary Island immigrants had already started gathering and accumulating in New Orleans, and with Galveztown quickly becoming stretched to its maximum capacity, Galvez appointed Lieutenant Antonio de St. Maxant as the settlement's commandant and began to direct the Isleños to Bayou Lafourche.

To better understand the settlement here, I decide to meet with three members of the Canary Islanders Heritage Association of Louisiana, a cultural group in Baton Rouge that represents Isleños who originated from Valenzuela. Rose Marie Powell, the organization's current president, and members Taylor Fernandez and Alisa Janney greet me after one of their society's meetings.

"Donaldsonville is located at the confluence of Bayou Lafourche and the Mississippi River," Alisa explains. "Bayou Lafourche was at one time an unnavigable waterway. But it flooded and made the alluvial plane so desirable to farm there and to actually create the settlements, and those were all Spanish land grants." Her hands snake through the air to show how the waterways intersect.

The Isleños arrived in the fertile lands of Valenzuela in March, even as St. Maxant hurriedly prepared for their arrival, constructed houses and gathered provisions. Although they remained dependent on rations in the beginning, the Isleños in Bayou Lafourche quickly transformed their land into something they could use. Levees were constructed and farmlands were marked. Larger families with slaves, animals and houses of their own moved farther away from the center of Valenzuela, but smaller families stayed together in the heart of the community.[17] They simply would have to share.

"They were actually given money to farm," Taylor says.

"They were expected to farm to survive," Alisa supplies.

Taylor goes on. "Most of them were farmers. They were allotted a certain amount of land, which might have not been large sections, but they grew their own vegetables, sugar cane and so forth and so on."

Starting a new town from nothing but the earth and a few provisions was never easy for the Isleños, but the Canary Islanders here had a better time than most from the other settlements. In the crucial early years, they avoided the disasters that hindered the growth of their cousins at Galveztown.

Unlike the popular association of Isleños with fishing and trapping that exists today, the Isleños arrived to southeast Louisiana primarily as farmers.

Nevertheless, despite their lucky start, Valenzuela did not totally escape nature's fury. In 1782 and 1783, the settlers got their first taste of water when floods damaged their crops and houses, but this setback was nothing compared to the seasonal woes of Galveztown or even Barataria. Armed with better fortune and better location, and without the burden of seasonally rebuilding, the Isleños weaned away from the government rations and established a stronger settlement. Valenzuela soon became a center for the Isleños in the region and often a haven for Canary Islanders from other less successful towns.

The Canary Islanders in Bayou Lafourche settled not far from a neighboring community of Acadians who had arrived in the 1770s in a place called Lafourche des Chetimachas. With no clear lines of authority, St. Maxant often bickered with the commandant, a man named Louis Judice, over boundaries and the location of a church.[18] However, even these disputes lent a sense of normalcy to the settlement. They were civil matters, not the muck and grim following a storm, and not the funerals after disease. Marriage and baptism records show that life for Valenzuela went on.

"Most of the Spanish were very strong in setting up the government situation in the state of Louisiana," Taylor says. "They were well organized when they came in."

"They were great record keepers, which has benefited all of us," Alisa adds.

"The Valenzuela area covers about five miles of Bayou Lafourche off of Donaldsonville," Taylor details, "and they were scattered all through there, the Spanish. It was all French at the time, and they didn't mix well in customs and so forth. Right off, they sort of separated themselves in different areas."

"I don't know why, but the history books do not have very much history about the Spanish," Powell realizes. "It's all about the French. It just seems like they overtook us. It's like the French had a stronger presence than the Spanish did."

In 1779, Spain declared war against England, and the Isleños quickly organized militia companies in case the nearby British in Bayou Manchac or Baton Rouge attacked their budding colony. Some Isleños from the area probably joined Galvez in his famous campaigns against the British at Fort Bute and Baton Rouge.

By 1794, only six years from the end of the Spanish period, the Isleños suffered damaged homes and fields when a hurricane hit the area. Commandant Verret begged for assistance from the Spanish government, but Governor Carondelet refused. Valenzuela, it became clear, was on its own. The Isleños had to recover by themselves. The time of rations and support was over.

Luckily, the Canary Islanders on Bayou Lafourche were able to survive and even thrive. With Galveztown and Barataria already struggling by the 1780s, the success of Valenzuela was a much-needed victory for the Isleño colonists. Without their survival and those in their sister colony called St. Bernard, the Canary Islanders in Louisiana might not be here today.

BARATARIA

In 1779, as more Canary Islanders gathered in New Orleans and waited for direction to their new homes, Bernardo de Galvez selected yet another site for the immigrants, a colony called Barataria that, unlike the others, was located across the Mississippi River on the west bank. If anything, the creation of Barataria demonstrated that Galvez was a capable military strategist but a poor selector of colony sites. Within four years of its establishment, Barataria failed.

From their earliest arrival, the residents of Barataria faced a battle against nature that they could not possibly have won. Barely living at sea level, the Canary Islanders there had to deal also with seasonal floods, storms and destroyed crops. Repeatedly, their attempts to start their town were thwarted: new construction collapsed from winds and floods drowned livestock and fledging crops. They suffered from many of the same problems as Galveztown in the north, but without the respite periods between disasters, their demise occurred much more quickly and with more severe results. Desperate and unable to provide for itself, Barataria continued to depend on rations from the Spanish government. The people could not survive without help.

Morale plummeted until the Isleños had endured enough and abandoned Barataria. The settlement lasted from 1779 to 1782, and even though a few intrepid families remained behind, most fled from the floods and disease. When Spanish support and funding trickled away until it stopped completely, many Isleños from Barataria left the failing settlement and moved to Valenzuela and to their more stable sister colony across the river, St. Bernard.

TERRE-AUX-BOEUFS

Just downriver from New Orleans, the fourth and final of the original Isleño settlements, St. Bernard, developed beginning in 1779 and has since become possibly the most lasting and most culturally cohesive of all the Isleño groups. Galvez designed St. Bernard, like Barataria, to serve as a defense against any potential invaders hoping to attack the city by coming up the Mississippi River, but unlike Barataria, St. Bernard survived its infancy and remains a town with its Isleño identity intact even today.

Several French plantation owners had resided in the upper parish closer to the city since the 1720s, but the Isleños settled in the lower reaches of the territory in a place called Bayou Terre-aux-Boeufs, the "land of the oxen." Originally known as La Concepcion and Nuevo Galvez, the settlement adopted the name San Bernardo by the 1780s to reflect, like Galveztown, flattery for their founder and chose to honor Bernard of Clairvaux, the patron saint of Bernardo de Galvez.

Whether by luck or prayer, the Isleños here in Bayou Terre-aux-Boeufs, like those in Valenzuela, did not suffer the same periodic disasters during

the colonial period as Barataria and Galveztown, and under the direction of Commandant Pierre de Marigny de Mandeville in these crucial early years, St. Bernard began to thrive. As farmers, the settlers were self-sustained by the 1780s. Some even began to dabble with fishing and trapping. By the early 1800s, farmers had extended their lands, branched to just outside the bayou on the city side, and founded what would become Violet.

Whether due to its success or its proximity to the city, St. Bernard became a haven for other Isleños, Spanish colonists and Acadians. When the American Revolution finally ended in 1783 and France and Britain declared peace, the Isleños who had been detained in Cuba finally finished their journey to Louisiana and came to St. Bernard, as well as Valenzuela. Many Spanish soldiers came to the parish, married Isleño girls and settled there permanently. In the 1780s, a few Acadians arrived in the territory and settled near the Isleños as well.

De Marigny repeatedly fought for the struggling settlers and negotiated with the Spanish government in the city to keep providing the rations, including food, clothing and tools, to widows and orphans in the community. However, when De Marigny left for France in 1788, he left his sub-lieutenant, Pierre de la Ronde, in charge of the St. Bernard settlement. Instead of returning to his post, De Marigny was elected to the Cabildo shortly after, and De la Ronde received the full position of commandant of St. Bernard in the early 1790s.[19] During his tenure, he planted at the site of his plantation a row of oak trees, which Stanley Clisby Arthur called the "finest double row of live oak trees in Louisiana" in 1931.[20] The trees—and the brick ruins of his house—still exist today.

New construction in the late 1780s and 1790s transformed St. Bernard from an array of scattered farms and houses into a community of settlers. In 1787, residents began construction of a St. Bernard church, designed by Francisco Delery. The church took three years to complete and remained in use until it was replaced in 1850. Three years later, in 1790, the Isleños petitioned Commandant De la Ronde for permission to build a tavern to complement their new church. In January 1791, in front of the construction site, the Isleños bid on permission to operate the local tavern. A woman also named Maria Hernandez won the bid and ran a tavern for an entire year before Gaspar Ortiz took over the responsibility.[21]

Throughout the lower parish, the Isleños formed pockets of small neighborhoods as they began farming the best land they could find. In 1783, a group of Isleños primarily from Gomera settled in Benchijigua

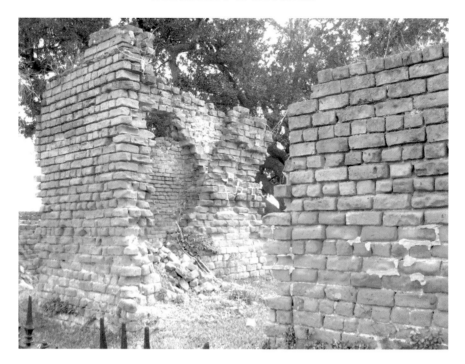

The brick ruins of the de la Ronde building on St. Bernard Highway show the blend of St. Bernard's past with its present.

in St. Bernard, named in honor of a mountain on their home island. The area soon became known as Benchique, as the Spanish language became corrupted by elements of French influence, and is now located where Reggio exists today.

Despite St. Bernard's success compared to the disasters at Galveztown and Barataria, not everyone was cut out for starting a new life from scratch. Even with rations donated by the Spanish government, colonial life in these early years of the settlement was difficult. Mosquitoes swarmed out of the marsh grass, and tending to crops in the summer heat was unbearable. Stuck in small houses without a church or a priest or any of the conveniences of civilization, many Isleños abandoned St. Bernard and moved to the comfort of the city, where they blended nicely into the melting pot New Orleans had become.

The failures and successes of these four Isleño colonies illustrate the magnitude of the hardships they faced after their arrival. Two settlements succumbed to disasters, and two managed to survive into the national period. Although some fared better than others, all had to deal with storms

and floods, sickness, mosquitoes and the swamp. Hundreds of men, women and children who came to the New World in search of a better life—one more prosperous than the drought-ridden, locust-plagued place they had left behind—nevertheless died from drowning and disease. Louisiana was far from the heaven they had hoped for.

Knowing what they faced, I keep thinking of hands—hands that let a newborn's fingers circle around his own; hands that gripped the side of the *Santisimo Sacramento* as it pulled away from familiarity and entered the sea; hands that wrapped around his wife's shoulders as they watched their first sunset on the open ocean and worked the strange land after they finally made it to Louisiana; and hands that held his head, his baby, his axe, seeds, the waves and the earth. Scraped and blistered, these hands matched those of all kinds of settlers from all kinds of colonies around the world—hands that worked tirelessly to adapt from the old life to which they could never return.

CHAPTER 2
AN AMERICAN EXPERIENCE

There is a kind of fish caught here called a catfish which nobody thinks fitting to eat but the Spaniards over the river, and there they sit with their dogs all day long in the sun, close to the water's edge, fishing and singing at their work. I love dearly to hear them; in the evening they build large fires along the bank for decoys, they look beautifully in the dark.
—Augusta of Alexandria, 1851

The Spanish period in Louisiana ended in 1800, less than forty years after it started. Napoleon Bonaparte, who was busy shaking up Europe in the effort to create a grand empire, pressured Spain into returning what was once French property. However, the Spanish colonists who had settled there did not have much time to leave. In 1803, the Louisiana Territory switched hands again, this time ending up as part of a foundling country, the newly created United States of America.

When Thomas Jefferson found out that France had once again seized control of Louisiana with the Treaty of San Ildefonso, he sent Robert Livingston to Paris to negotiate the purchase of just the Isle of Orleans. France had other plans. Napoleon had dreams of eventually amassing a North American empire, which would certainly include the port in New Orleans, the gateway to the entire territory. However, before he could begin reestablishing French governance, two key events dashed his hopes of ever creating his North American dream. A slave revolt in Saint-Domingue succeeded in expelling the French from the island now known as Haiti, leaving France without an ideal staging ground for Napoleon's New World plans and without the wealth of this major sugar island. In addition, Napoleon

needed a time of peace to focus on restoring French power to Louisiana, but the outbreak of war with Great Britain kept him distracted. Without Saint-Domingue and with war with England consuming his time and resources, Napoleon abandoned his goals of establishing a North American empire and looked for a buyer.

He did not have to look far, since both Robert Livingston and James Monroe were already in Paris by now, trying to buy the Isle of Orleans from France at a cost of $10 million. In desperate need of money and glad to be rid of the burden that Louisiana had suddenly become, Napoleon offered the entire Louisiana Territory—from the Great Mississippi to the Rocky Mountains and as far north as British-controlled Rupert's Land by the Hudson Bay—for the bargain price of $15 million. It was a steal. Although they were only authorized to buy New Orleans, Livingston knew that the offer was too good to refuse. On April 30, 1803, they signed the Louisiana Purchase Treaty and doubled the size of the United States.

After the Louisiana Purchase, land prices in the Isle of Orleans skyrocketed, and many Isleño landowners sold out to incoming Americans, who bought the properties of these small farmers and pieced them together to form larger, plantation-styled holdings. With their new money, many Isleños moved closer to the bayous to start new farms, and most maintained crops at a subsistence level.

Government began to change, and America quickly defined its leadership role in the Louisiana Territory. Parishes, Louisiana's system of counties, were organized and created; parish judges were appointed and police juries formed; and in 1812, Louisiana became an official state.

Back in the Canary Islands–decorated living room of her house, Dorothy Benge sits upright in her chair as I broach the subject of the Louisiana Purchase.

"How did things really change for the Isleños?" I ask.

"Well, the Isleños have always been—were—isolationists," she says slowly. "They like to be left alone in the parish, and the parish was very isolated, especially in 1803. In fact, it wasn't until really World War II that they began to assimilate with the rest of the country."

"So things didn't change when they became part of the United States?" I ask.

"After 1803, things more or less stayed the same," she explains. "They did their thing; they went on doing their thing."

"It's so weird to think that they became a part of an entirely different nation, and nothing really changed," I suggest.

"Well, the parish is isolated from the rest of the state," she says again. "Nobody passes through St. Bernard to get to anywhere else. In fact, if you go down to Delacroix Island—I don't know if Katrina took the sign—but there was a sign: 'The end of the world.'"

Regardless of the invading American presence, most Isleños, happily isolated, sunk back into the farmlands and marsh and continued life peacefully as farmers and fishermen.

However, this self-inflicted seclusion briefly ended when President James Madison and the United States Congress officially declared war on England in the War of 1812. Problems with Britain had been going on for a while. After a short-lived truce in 1802, the Napoleonic Wars resumed in Europe, and England imposed several restrictions that obstructed American trade with France. The British also exercised impressment and seized "British deserters," who were often American sailors, and forced them into the Royal Navy. England also egged on and sold arms to the Native Americans, who fought Americans trying to push toward the western frontier. Aggravated and dismayed over the failure of Jefferson's Embargo Act of 1807, the United States declared war in 1812.

The war, of course, had its perks. Battles allowed this second generation of United States citizens to prove their mettle against England, just as their fathers had done in the American Revolution. Victories against the British, such as that in Baltimore, united the country, inspired the lyrics of "The Star-Spangled Banner" and prompted the "Era of Good Feelings," which dissolved most internal political dissidence.

But deep in the heart of Louisiana, the Isleños remained the same until 1814, when, if only for a short time, everything changed. The French and Spanish in Louisiana had only been assimilated into America eleven years before, and Americans, French and Spanish alike all wondered where their allegiance would fall when the dice fell. After all, they had no strong ties to the United States, and even though they had taken fairly well to American control, no one was sure if this country was worth fighting for.

Whatever their potential misgivings over dying for an American cause, hatred for the British quickly trumped any hesitation or doubt. The population of southeast Louisiana still included overwhelming numbers of French and Spanish, Great Britain's traditional enemies for several centuries, so when a British fleet defeated the American naval force stationed at the

mouth of the river in the Battle of Lake Borgne on December 12, the local Isleños began to prepare for the inevitable land battle that would soon follow.

Although they had no way of knowing, the British sealed their fate when they began stealing livestock and terrorizing the Isleños and others scattered around the New Orleans periphery. The invading and unwelcome soldiers seized horses and cattle and destroyed crops as they battled their way toward the city. After landing in Fisherman's Village in Bayou Bienvenue, the British captured the residents of the small palmetto-thatched village. According to Gilbert Din, an Isleño man named Antonio Rey was one of only four who managed to escape the assault. Rey ran to the marshes, and for three days he trekked tirelessly through the mire and muck to warn the other towns farther up the river.[1]

But Rey did not have time to reach the others. On December 23, 1814, British commander John Keane led well over a thousand soldiers to the east bank of the Mississippi River and stopped to wait for reinforcements just nine miles south of the city. That night, General Andrew Jackson launched an attack on the British at Villeré Plantation in St. Bernard, catching them by surprise with his hardy mix of American troops and local volunteers, which included many Isleños from the area. By the end of the unusually cold night, Jackson and his men withdrew to the safety of a nearby canal, but he had not left Keane with a clear victor. Both sides sustained casualties, and even though Jackson had been the one to retreat, the British lost much of their daring to caution. They now realized that New Orleans would be no easy conquest. They did not move to take the city the next day or even the next. Instead, as General Edward Pakenham assumed command of the British soldiers, they watched and waited and plotted only a few miles from the too vulnerable city.

"What happened to the parish?" I ask Benge.

"The British plundered St. Bernard, took the cattle and the food and whatnot," she replies.

Meanwhile, as the British waited, Jackson wasted no time to take measures necessary to defend New Orleans. He took advantage of the British forces' inactivity and constructed a defensive position composed of artillery-protected earth mounds. Desperate for naval cover, Jackson reached out to pirate Jean Lafitte and offered a pardon to Lafitte and his men if they agreed to defend the city against the British. Lafitte agreed, turned from pirate to privateer and worked with Jackson to organize the American defense and repel the British in several skirmishes.

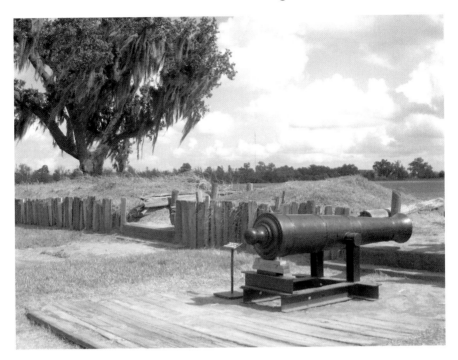

The Battle of New Orleans allowed the Isleños an early opportunity of an American experience. Spanish and American militia fought alongside one another to defeat a common enemy.

On the morning of January 8, 1815, still under the mask of predawn darkness and winter fog, Pakenham made his move. The British army launched an attack against the entrenched American forces and militia and suffered more than two thousand casualties.

"I'm sure the Isleños participated," I say.

Benge nods. "They participated. There's a muster list of all the people who fought in it, and there are many, many Isleño names on the list."

Although the actual fight is now known as the Battle of New Orleans, the skirmishes took place in Chalmette in St. Bernard Parish. The location of the battle prompted the Isleños to participate to defend their homes from the British invaders.

Benge continues. "My grandmother—another bedtime story—used to tell me this story. Some of the British came through and were looking for directions to the battlefield in Chalmette. Of course it was only the women left because the men were over there fighting. She said the women would tell them which way to go, but they'd tell them the *wrong* way." She starts to grin.

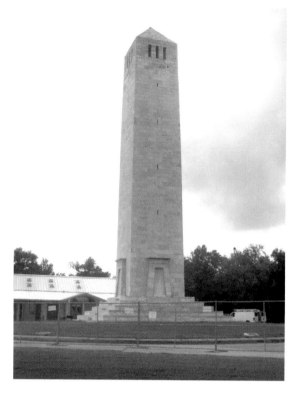

On the site of the Jean Lafitte National Park, the Battle of New Orleans monument stands as testament to the Isleños' involvement in the War of 1812.

"And they used to laugh at all the British lives they saved because they never made it to the battle!"

I laugh.

Jackson's ragtag group of soldiers, militia, Native Americans, African Americans and Isleños managed to defeat the professional British soldiers, who soon withdrew to Lake Borgne and escaped to the Gulf. The American victors, having proved themselves as fierce and patriotic as the generation before them, celebrated with their Isleño comrades by chopping Pakenham into several pieces, stuffing him into a barrel of ale and shipping him back to his home in Ireland. With such a victory, no one really cared when word came from Europe that the Treaty of Ghent had ended the war two weeks before the Battle of New Orleans took place.

After the Battle of New Orleans, routines for most Isleños returned to normal, but changes seeped through the cracks and into their lives. If it accomplished anything, the Battle of New Orleans boosted morale for the entire country, brought Isleños and Americans together under the same banner to defend their shared home and encouraged Britain to adhere to the terms of the Treaty of Ghent. After the War of 1812 ended, more Americans came to the New Orleans area and began to force themselves into the Isleño tapestry.

Riverboats and steamboats floated down their river, and the city grew larger. More plantations sprang up in upper and central St. Bernard, although

Delacroix Island remained in the hands of small farmers, fishermen and trappers. In Bayou Lafourche, where sugar cane reigned supreme, a few Isleños actually owned plantations themselves and grew very wealthy in the decade before the Civil War.

For the most part, however, the Isleños continued to work their small farms on a near-subsistence level and sold whatever surplus of onions, sweet potatoes and other vegetables they had to the New Orleans French Market. They worked together in communities, respected their elders, distrusted outsiders and kept staunchly to their ways. The popular image of the backward, country-minded Spanish began to emerge as the rest of the nation entered a period of progress and innovation. Isolated, the Isleños did not participate in these changes. The marsh and the fields, after all, stayed the same.

Interestingly, it was a man from St. Bernard Parish who next changed their world. On April 12, 1861, General P.G.T. Beauregard, born on a plantation in St. Bernard, fired the first shots of the American Civil War at Fort Sumter and forced guns back into the hands of Isleños.

The Civil War once again shook the Isleños, both in St. Bernard and on Bayou Lafourche, out of their everyday existence and thrust them back into national affairs. Forty-five years before, the Isleños had fought against the British to defend the nation of which they had recently become a part. Now they stood on the brink of a divided nation fighting itself. Like most other poor whites, the majority of Isleños did not own plantations or slaves, but the Southern cause spread like marsh fire across the state, and several men, including future politician Albert Estopinal, joined the Confederate army with pride. On the homefront, farmers and fishermen struggled with dismal trade and rapidly rising prices. Although there is little evidence to indicate how involved the Isleños truly were in the war, passed-down stories and surviving documents from typically Canarian areas demonstrate that as Louisiana entered the war, so did the Isleños.

Less than three months after seceding from the Union, Louisiana joined the Confederacy in March 1861. Full of fervor and the near-universal assumption that the war would be brief, twenty thousand Louisiana men rushed to enlist within the first nine months.[2] It did not matter that only some Isleños on Bayou Lafourche owned and depended on slaves; almost all Isleños, slave owners or not, accepted social conventions and the South's prevailing racial hierarchy. As a result, Isleños joined the Donaldsonville

Artillery or enlisted in the St. Bernard Mounted Rifles and the Miles Legion to fight for the cause.

By the spring of 1862, Louisiana had become a hot spot in the war. The Union, hoping to choke the South by cutting off its access to the Mississippi River, appeared at the mouth and began to worm its way toward the city. The Confederate troops quickly declared martial law, but their efforts failed to prevent the Union takeover. In April 1862, Union flag officer David Farragut, who would later become an admiral in the United States Navy, led a menacing fleet of eighteen ships and six steamers up the Mississippi. Forts Jackson and St. Phillip below New Orleans futilely attempted to combat the formidable force, but after six days of bombardment from the shore, Farragut made his way through and reached a vulnerable New Orleans. The current mayor, a man named John Monroe, valiantly refused to surrender the city, but his gesture, although portrayed as noble by Southern supporters, was unfruitful and largely meaningless. By the end of April 1862, the Union had control of the city, and Major General Benjamin Butler assumed authority of New Orleans and the surrounding areas.

For the Isleños, Union control of the area meant economic woes. Prices for basic necessities and food spiked, and with crops ruined out of spite and in skirmishes, the Canary Island descendants struggled, just like others all across a barren, broken South.

The Isleños still living on Bayou Lafourche suffered the most of all the Canarian territories in Louisiana. With its extensive sugar industry and wealthy plantations, Bayou Lafourche was a prime target for invading Union troops. Soldiers stole livestock and leveled towns. The area was sacked and looted and burned. In July 1863, Confederates in the area succeed in retaking control of where Valenzuela once stood in the Battle of Kock's Plantation, but the residents struggled to restart their lives amidst the floundering Southern economy.

Although a few Isleños did own slaves and plantations, the Civil War was a fight over something the Isleños did not have a real stake in; the war still drew them in anyway, involved them and encompassed their lives. For them it was a fight over ideology, and for that the Isleños were willing to grab their guns and follow the Confederate call. Before war, the Isleños had a fairly pleasant relationship with the local blacks, but the war focused attention on race relations and stressed a dichotomy between who was white and who was not. As a result, the Isleños sided with their European brethren and often defended slavery with bullets and words, even if they often owned no

slaves themselves. For poor whites like the Isleño farmers, the Civil War was a long, bloody fight for their beliefs that ended up costing them time, fields and friends and left them much worse than they had started off.

After five long years of nearly dead commerce, poverty, turmoil and disaster, the Isleños accepted news of General Robert E. Lee's surrender to Ulysses S. Grant at the Appomattox Court House, but like everyone else, the Isleños hunted for someone to blame for their postwar hardships and settled on the newly freed blacks. Like many other poor whites in similar situations, the Isleños quickly began to resent the freedmen and blamed them as the cause of their economic struggle.

In October 1868, mounting racial tensions finally turned violent in St. Bernard Parish. Two years earlier, a riot in New Orleans had left thirty-four blacks and three white Unionists dead, but with the presidential election of 1868 right around the corner, more whites began to terrorize newly freed blacks into avoiding election polls in an attempt to secure a Democrat victory.

On the morning of October 25, parish Democrats marched to St. Bernard Church so that the priest there could bless the flag of the Bumble Bee organization. On the way, a group of white men tried to force freedmen to shout an endorsement for Horatio Seymour as president. When the blacks refused, several men, including freedman Eugene Lock, drew their weapons. The white agitators shot and killed Eugene and wounded two others and launched the chaos of the St. Bernard race riot. It was a Sunday.

As freedmen began to panic in fear of a massacre, Republican plantation owner Thomas Ong tried to alleviate the tempers in St. Bernard, but it was already too late. Mike Curtis, a police officer with known affiliations with the Republican Party, rode to help preserve order before the situation worsened. That night, as he neared the courthouse, Curtis encountered a group of armed whites who forced him to identify himself. Hesitantly, Curtis told them his name. The whites promptly fired, killing Curtis and a freedman who had witnessed the shooting.[3]

Within hours, Ong knew about Curtis's murder, and loyal freedmen surrounded his plantation to protect him from the riot leaders. Ong realized, however, that their presence would only stir up additional trouble, and he sent them home. Although they initially refused, they eventually left the plantation but stopped by the business of baker and store owner Pablo San Feliu on the way and demanded alcohol. When an argument escalated, San Feliu broke out his shotgun, killed one man and wounded others. The blacks

The grave of Pablo San Feliu, who was killed in the St. Bernard race riot.

attacked San Feliu in retaliation, killed him and set his home on fire. They did allow his Isleña wife and children, terrified from the horror of the fire and the murder of Pablo, to flee to New Orleans.[4]

As the ashes of San Feliu's store and body met the first rays of daylight on Monday morning, the violence of the riot entered its peak. Following the records of New Orleans newspapers and the testimonies of eyewitnesses, Din asserted that "disorders, killings, and looting erupted almost everywhere in the parish, with all the victims now being black."[5] A group of mounted and armed whites appeared mid-morning, but instead of restoring a sense of order, they kidnapped Dr. M.L. Lee, who had tried to mediate between the blacks and the mounted whites, and fired at a group of freedmen, who ran into the cane fields of the plantations to escape. They captured and killed several black prisoners; the killings and destruction continued across the parish. Chaos was everywhere. Posses roamed the streets, and families fled up the road to the safety of New Orleans. A group of whites posing

as deputy sheriffs tried to arrest Republican Ong, who refused to leave the haven from hell that his plantation had become.

The riot continued for several days with dwindling enthusiasm and violence, but the greatest damage was already done. Several other "deputy sheriffs," claiming to be under the authority of Judge Philip Toca, arrested freedmen, who were later released by city authorities. Eugene Joseph, a black man, was shot in the lung, thrown into a cart and brought to the courthouse on November 1. In the end, two whites and nine freedmen were killed, and more than a dozen men and women were wounded. Countless properties were damaged, but although racial tensions most definitely remained and still remain, the parish began to heal. Today all that truly remains from the race riot of 1868 is a lone headstone at an overgrown grave near the front of the St. Bernard Catholic Cemetery—"Pablo San Feliu, Assassinated by Slaves, Incited by Carpetbag Rule." However, the wrong death date illustrates that although the memory of details faded, the feelings of resentment and hatred and blame still remained. The riot did succeed in intimidating blacks and scaring them away from the polling places in November, but despite their best efforts, their best threats and their best guns, these parish terrorists did not prevent Ulysses S. Grant from cinching a Republican victory in the 1868 presidential election.

After the Civil War, the Isleños returned once again to their isolation, whether near Bayou Lafourche or Bayou Terre-aux-Boeufs. They were now a little worldlier but still deeply rooted in their old ways. Like most poor whites across the ravaged South, many small farmers lost their land and became politically disenfranchised thanks to poll taxes and literacy tests during the Bourbon Age of politics. In a reality where the Isleños still spoke Spanish and tended to small farms, one can speculate the social changes caused by their political and economic situation.

As farms offered less and less happiness and stability, it makes sense that the Isleños looked to other options for a better life, and sure enough, a push for education among the Isleños occurred during the end of the Reconstruction period. This encouragement of education began in the 1830s but with only a few voices of support. Din recorded that "in 1851 only forty-five boys and twenty-nine girls attended school in St. Bernard Parish, a fraction of the total young population."[6] A few more schools emerged in the more populated portions of the parish, but teachers received little pay and were often women who quit working as soon as they were married. In 1894, the editor of the *St. Bernard Voice* reprimanded the Isleños for their disregard for

education. That same year, however, the first school in Delacroix opened. Students often abandoned classes during harvest or fishing seasons to help their parents, but the effort and precedent had been made.

Just before the turn of the twentieth century, historian Alcée Fortier traveled down to St. Bernard Parish and commented on the primitive existence of the Isleños. No one would have ever guessed by looking at these Spanish communities in the late 1800s that the car and the telephone were being invented, that railroads connected a vast nation or that Louis Pasteur was testing the earliest vaccines for rabies. Outside, it was a world of progress, but the Isleños lived like they did during the colonial period. With the eyes of an outsider, Fortier looked at the simple existence of the St. Bernard Isleños, like Europeans taking their first glimpse of the supposed childlike, uncivilized Native Americans. However, Gilbert Din wrote in *The Canary Islanders of Louisiana* that "on the journey to New Orleans, Fortier contrasted his own life in the city—that of a civilized man who enjoyed luxuries—with the Isleños' simple existence and ambitions. Fortier failed to realize that the Delacroix Island inhabitants clung to their way of life because they knew no other."[7]

The end of the nineteenth century established factors that would later influence the Isleños to varying degrees. In the 1880s, a large number of Sicilians and Italians, looking to escape instability and corruption, came to New Orleans and began to mix with the Isleños. Natural gas was discovered in northern Louisiana, and by 1901, the first oil rig in Louisiana was completed in Jennings Field. By 1909, Standard Oil Company had recognized St. Bernard's supply of oil and built petroleum storage tanks in Chalmette. The Bayou Lafourche area received electricity in 1900. Big businesses moved into the parishes, and the Isleños were torn between the safety of the old world and the allure of the new.

Although the Isleños made no real efforts to join the world beyond, disasters nevertheless kept them from progressing internally. Hurricanes hit southern Louisiana in 1887, 1892 and 1893. The Mississippi River's bank collapsed in 1892. That same year, St. Bernard established its first parish newspaper, the *Weekly Eagle*, which summed up the Isleños in a single line when it described them as "principally…hard-working men, but inadequately rewarded, who travel daily from this point to the city to supply the markets with fish, crabs, shrimps, and game, from which they derive their existence."[8] The writer hit the nail on the head. By this point in their history, the pattern of Isleño existence had been clearly established—simple lives based on self-isolation and tradition, with periodic events that forced them to acknowledge the outside world and the nearly constant need to rebuild, recover and start over once again.

CHAPTER 3
PART OF THE WORLD
THE ISLEÑOS IN THE TWENTIETH CENTURY

From that unknown submerged island
only small extensions remained
of rocks, mud, trees and hills.
A reduced group of battered Atlantans
anxiously united their bravery
to survive, to go on counting
suns, harvests, children, and hope.
—*Justo Jorge Padrón, "Fifteenth Canto: The Guanches" (translator, Louis Borne)* [1]

The twentieth century brought changes to the Isleños of southeast Louisiana in ways that the trappers, farmers and fishermen of the previous century could never have imagined. Suddenly the world did not seem like such a big place. Two world wars shrank the globe and drew local boys beyond the marsh for the very first time. Interstates, railroads and new technologies connected all of the corners of the country, even in a place where solid ground itself began to end. Various disasters, both natural and political, forcefully tossed many Isleños headfirst into modernity. Times were changing fast in the twentieth century, and the Isleños, who had barely changed at all for the last one hundred years, stood at the brink of a foreign crossroad.

World War I started in Europe in 1914 shortly after the assassination of Austro-Hungarian heir Archduke Franz Ferdinand and his wife, Sophia, but in the three years before the United States Congress formally declared war, the Isleños faced their own problems. In 1915, a devastating hurricane

flooded nearly all of St. Bernard Parish and destroyed schools, businesses and homes. In his book, Gilbert Din reported that the storm claimed more than thirty lives, but like always, heroes emerged from the survivors.

"During the storm, Robert Serpas sheltered 125 persons," he wrote. "Congressman Estopinal, his son Sheriff Estopinal, and others immediately organized relief parties to help the victims. Henry Morales volunteered his house as a center to receive clothing and other items for the needy."[2] In 1916, the St. Bernard church suffered a terrible fire that damaged the building beyond repair. A new church was not constructed until 1926. A few years later, disaster struck again when a portion of the Mississippi River bank collapsed, destroying recently rebuilt homes and drowning livestock. Defeated, overwhelmed and frustrated by this string of misfortunes, many young Isleños looked away from the devastated parish for new opportunities.

World War I was their ticket to what they hoped was a better world beyond. Hundreds enlisted and registered for the draft when Congress issued the declaration for war in 1917, and many were called to serve. Like everyone else across the nation, others who were not in the armed forces served on draft boards, endured a series of rations, raised money and volunteered for the Red Cross. Not everyone went overseas, but the war brought a temporary shift in lifestyle for the residents of southeast Louisiana that broke the age-old routine of life in the marsh. Din summed up these changes by saying, "World War I drew more of the Isleños away from their native parishes and made them feel a part of the nation. It enabled a number of them to travel to other regions of the United States. Some of the Canary Islanders developed a greater appreciation for education, as college graduates usually became officers."[3] Despite the acquisition of this new and slightly worldlier viewpoint, most Isleños moved back home after the war ended—except they returned with an array of experiences that they never would have received within parish lines.

Whatever the potential outcome of those experiences, events that occurred over the course of the following decade turned Isleño attention back to St. Bernard. In 1920, Prohibition, which had been established the year before by the ratification of the Eighteenth Amendment, went into legal effect across the country. Organized crime might have been started by men such as Al Capone because of this absurd ban on alcohol, but the Isleños of St. Bernard did their fair share of breaking the rules, too. With such a proximity to Cuba and international waters, many residents used their knowledge of the marsh to run bootlegged liquor to the gambling houses

in New Orleans. Parish officials were often involved in the illegal activity, so the Volstead Act, which enforced Prohibition, was generally ignored. To this day, abandoned bottles and crates can be found in the inlets of the canals and lakes. These local contraband dealers sometimes disguised their looted as canned vegetables or jars of molasses, and Glen Jeansonne even reported a case in which a funeral carriage was used to complete the run to the city. In fact, bootlegging was so common in the parish that it prompted one researcher named Bryan Gowland to remark: "Matter of fact, running whiskey was almost an honored profession in St. Bernard Parish. *Hijacking* whiskey was a real crime!"

By 1926, the St. Bernard Isleños began to encounter a sequence of local challenges that put their community to the test. Hollywood's leading fashion icons contributed to the rising popularity—and the subsequent rising cost—of fur. On the surface, this was a blessing for the Isleño trappers. This was long before the introduction of the overbearing nutria population, and muskrats swarmed the marshes of St. Bernard, especially near Delacroix Island in the lower reaches of the parish. Even better, no one officially owned the land, so the trappers roamed the marsh free from the burden of leases and hunted the muskrats for their pelts and for profit.

However, when the demand for fur exploded in the 1920s, wealthy landowners across the state rushed to obtain property rights to the marsh and lease the land to outside trappers, leaving the Isleños stunned and confused over their broken tradition. What followed was their violent struggle to combat the political forces mounting against them. Tooth and nail, legally and lethally, the Isleños fought to maintain what they felt was rightfully theirs in a battle now called the Trappers' War.

Bryan Gowland, the former mayor of Abita Springs, grins as we sit down beside an antique typewriter in the small Abita Springs museum. A St. Bernard native, he is the author of the article "The Delacroix Isleños and the Trappers' War in St. Bernard Parish," which he presented as part of his master's thesis at Southeastern Louisiana University. Intrigued by the stories he heard growing up, he began researching his family's own personal experiences with the political turmoil that engulfed the parish in 1926.

"Before they found out that furs were so valuable, nobody knew or cared who owned the land down in the marsh," he tells me. "The people at the island were pretty free to travel around, hunt and trap with no restrictions. But all of a sudden, the marsh had value because the furs had value."

With the sudden intrusion of outsiders and the encroachment against their tradition, the Isleños now faced a new dilemma, one that they did not fully understand—legal ownership of the marsh. Land grabbers snatched huge chunks of the marsh, and the Isleños proved unwilling to pay leases for the right to do what they always had done. Suddenly, the Isleños "encountered something they had never seen before: no trespassing signs. The trappers, who had used the land unencumbered for generations, now had to pay for the right to trap or risk arrest and prosecution for poaching."[4] But the Isleño trappers depended on the muskrats for their season's income, and they realized that they needed help navigating through the political and legal confusion beyond Delacroix Island. Fearing corruption over the uncertain terms of the proposed leases, the Isleños hired Plaquemines Parish's political boss, Leander Perez, to legally protect their interests.

Leander Perez, who has been lauded and criticized, dissected and disrobed, by contemporaries and scholars, stands as one of Louisiana's many colorful politicians. Leander created a political monopoly in Plaquemines and St. Bernard Parishes in the first half of the twentieth century. He influenced the outcomes of elections, successfully defended Huey P. Long in his impeachment trial and diverted government funds. After a conflict with the Catholic Church over segregation during the civil rights movement, he supposedly tried to create his own church called the Perezbyterians. In his book, Din delicately claimed that Leander, who did not acknowledge any Isleño lineage, asserted that "the name Perez reportedly originated with a Spanish sea captain from Madrid; but Isleño descent is more likely."[5] Whatever his heritage, Leander certainly left an impact on all of the people in southeast Louisiana, French or Spanish, white or black.

The Trappers' War took place in the beginning of Leander's political career but hinted at the methods that would later define his political regime. Gowland states that Leander organized the St. Bernard Trappers' Association and brokered a deal for a reasonable lease payment in exchange for the Isleños' right to trap.

"Well, the trappers were initially told they would have to pay a lease," Gowland explains. "It was a satisfactory lease, and they initially agreed to pay the lease and go ahead and trap."

"Sounds like a done deal," I say. "So what happened?"

"They had a meeting at the St. Bernard Courthouse, and Manuel Molero entered the picture."

Perez, in league with the leaseholders, used his position of power to take advantage of the Isleño trappers. As they soon found out, Leander's cousin, John Perez, held the leases, and even though he and his cousin were already profiting, they devised a scheme to earn even more. They planned to transfer lease holdings to a trustee, J. Walter Michel from the city, and draft new leases for the Isleños. Even worse, "Each trapper had to be personally acceptable to Michel, and John R. Perez could cancel the lease by using his option to purchase."[6] The fifty-dollar annual fee tripled, and the Isleños were left stunned and betrayed.

On April 12, 1926, hundreds of Isleños met with the St. Bernard Trappers' Association and demanded that Michel's titles be revoked. When Leander became defensive and refused, they desperately turned to one of their own, Manuel Molero, for help.

"He kind of caught onto Perez's game, and he accused Perez of manipulating the trappers on behalf of the company charging the leases—and that he was double-dealing. And then Perez accused Manuel Molero of lying, and actually, the two guys had to be pulled apart at that meeting."

That was far from the end of the argument. From there, a clash ensued between anti- and pro-Perez factions of the parish. As the price of leases exploded and as Perez continued to loan government money to his political allies, who purchased more and more of the marsh away from the local trappers, the brewing battle over the St. Bernard Trappers' Association went to court. The judges voted in favor of Molero, but Perez appealed as trapping season approached. The district courts supported John Perez's claims to the land and ruled against the Molero faction of trappers. When the court's decision failed to deter Isleños from entering the marsh anyway, Leander hired armed guards and out-of-town trappers, who swept into the marsh and readied themselves to hunt the muskrats for the pelts. Tensions quickly mounted; the unwelcome guards and outsider trappers clashed and accused one another of threats, thefts, the burning of the marsh and cabins and murder. In mid-November 1926, the Isleño trappers of Delacroix Island invaded the marsh, expelling the outsider trappers hired by Perez. Furious, the pro-Perez faction in the parish decided to take revenge.

On November 16, 1926, a group of men, including a former justice of the peace named Sam Gowland, headed down to Delacroix Island with guns and fury.

"What happened?" I hurry and ask.

Proudly proving that he still has St. Bernard habits even after moving to the Northshore, Gowland immediately starts talking excitedly with his hands. "They went down to Caernevorn by Caernevorn Canal, and they commandeered a boat the *Dolores*, which was an oyster lugger. Belonged to a guy name Marbalo, and they forced him to actually pilot the boat. And so they went through Caernevorn Canal to Lake Lery and eventually into Bayou Gentilly."

Armed to the hilt with everything down to machine guns, the pro-Perez trappers rounded the bend at Bayou Terre-aux-Beoufs to Delacroix Island at about eight o'clock in the morning.[7] Gowland continues:

> *Now somebody found out. Of course, being from down the road, you know, my mother used to say if you went to the bathroom on one end of the island, by the time you got out, somebody on the other end of the island knew that you had been in the bathroom. So anyway…that's how word travels down there. The people on the island knew that the boat was coming.*
>
> *Well, the boat came out of Bayou Gentilly into Bayou Terre-aux-Beoufs, and when they rounded the bend, they noticed that the levee on both sides of the bayou was—there was about, maybe two hundred armed men on the levee.*

"Whoa," I say.

The shootout that ensued resulted in only one casualty—Sam Gowland, the former justice of the peace, who had been manning one of the machine guns.

"Eventually the Isleño guys came out and captured them and brought them to shore," Gowland says. "All of them were wounded—several of them had fractured skulls, a lot of them had buckshot wounds. One of them burned himself on the manifold of the motor trying to dive in the bottom of the boat."

Gowland retells the account of John Asher, a former Texas Ranger whom Leander had hired to protect the marsh. He was there on the *Dolores* and estimated that "six or seven hundred armed men lined both banks of the bayou."[8] He had guns strapped to his sides but maintained that he never fired a single shot. At some point during the firefight, a bullet "punctured the fuel tank, disabling the *Dolores*, causing her to drift until she became lodged on a sandbar."[9] Asher and the others swam to shore and came face to face with the furious Isleños.

Gowland says, "Anyway, they were taken ashore and claimed they were beaten into signing a piece of paper that said that they had shot first!"

The Isleños were not done. Enraged, they sent their women and children away to safety and hacked down trees to block access to the road that led to Delacroix Island. Then they turned to Plaquemines Parish to confront Leander, who promptly fled with his family across the Mississippi as soon as he heard of their approach.

In the aftermath of the Trappers' War, Louisiana governor Oramel Simpson traveled down to St. Bernard at Sheriff L.A. Meraux's request. Meraux, who had been in league with Perez for years, was involved in lease plots that instigated the Trappers' War and wanted to bring the Isleños to justice. Unable to find any of the weapons that Meraux claimed the Isleños used against Leander's trappers, the governor returned to Baton Rouge without any evidence and without any need to declare martial law.

Gowland states that the Trappers' War ended on November 23, one tense week after it started. Manuel Molero mortgaged everything that he had to raise the money necessary to purchase the marshlands from John Perez. He then leased the land to the Isleños, just in time for trapping season. He claimed that he wanted no interest and no mark up—the Isleño trappers would pay him exactly what he paid for the land.

Gowland concluded his master's thesis by suggesting that the Trappers' War forced the Isleños to fully confront the twentieth century, and this gradual shedding of the once trademark Isleño isolation escalated throughout the early 1900s until, by World War II, the Isleño identity had fused in part with the local French, American and the incoming Sicilians.

All in all, the Trappers' War was just another violent stage in a long and violent history—from their wars against nature to the American Revolution, the Battle of New Orleans, the Civil War and World War I. In the aftermath of the 1926 shootout, the *New Orleans Item* eloquently captured the continuous conflict of the Isleños and predicted the grim future of the insular people: "For the roots of the Trappers' War go deep into the human heart of a race of men who fight the elements for their daily bread, for the bread of their women and their children—and battle is a tradition with them."

The idea of this never-ending battle—against local government tyranny and against the elements—continued into the following year with the dramatic Flood of 1927. Heavy rains drenched the land in the central Mississippi River basin throughout summer and fall of 1926 and well into 1927. Arkansas,

Mississippi, Tennessee, Kentucky, Oklahoma, Kansas, Illinois, Missouri and Louisiana were left soaked, and all along the main course of this swollen river and its tributaries levees were strained to the verge of collapse.

In his award-winning book *Rising Tide: The Great Mississippi Flood of 1927 and How It Changed America*, John M. Barry described it quite poignantly:

> *There is no sight like the rising Mississippi. One cannot look at it without awe, or watch it rise and press against levees without fear. It grows darker, angrier, dirtier; eddies and whirlpools erupt on its surface, it thickens with trees, rooftops, the occasional body of a mule. Its currents roil more, flow swifter, pummel its banks harder. When a section of riverbank caves into the river, acres of land at a time collapse, snapping trees with the great cracking sounds of heavy artillery. On the water the sound carries for miles.*[10]

In New Orleans, the city's leaders certainly heard the sounds of the river, and as the waters rose beyond record levels in nearby Greenville, Mississippi, they began to take precautions. Barry reported that "three thousand city workers and the National Guard frantically struggled to raise the levees higher,"[11] but the *Times-Picayune* attempted to diminish the gravity of the dire situation by reducing coverage of the rising waters to single buried paragraphs or even, at times, nothing at all. However, when the *New Orleans Item* published a quote from the chief of the United States Weather Bureau's regional office predicting an unprecedented river high, the mayor of New Orleans, a man named Andrew Shane, went so far as to promise the safety of the city in a futile effort to maintain a sense of calm.

Whatever peace of mind his speech might have brought to some instantly faded on April 24 when a levee in Myrtle Grove gave way to the pressure of the mounting water. Two days later, Barry wrote, "[N]ear Ferriday, Louisiana, across the river from Natchez, Mississippi, two tiny sand boils, barely an inch in diameter and shooting water only a foot high, erupted. Less than five minutes later, the levee abruptly caved into the river. Soon the breach exceeded 1000 feet in width. The river roared through in giant billows, waves exploding as high as the tops of trees, forcing 20,000 people from their homes."[12]

In a panic now, the New Orleans residents and city leaders demanded action stronger than sandbags and prayers. As a result, only days after the *Times-Picayune* reaffirmed its faith in the officials in charge of the crisis, city engineers at the order of the governor, the mayor and several

city businessmen blasted river levees at Caenarvon (near Poydras and Braithwaite) with dynamite and forcefully created a crevasse to save the city. "By luck the Poydras crevasse killed no one," Barry wrote, "but it ultimately reached a width of 1500 feet and dug a hole 90 feet deep where the levee had been. The levee itself added 25 feet of height. That meant that a moving mountain of water nearly 1500 feet wide and up to 115 feet high—as high as an eleven-story building—exploded onto the land."[13] The city was spared.

Within days, New Orleans citizens breathed a collective sigh of relief as they watched the river's level gradually ebb. The crisis was passing, and the price that they had to pay was conveniently downriver and far out of sight.

Of course, those officials responsible for allowing the blowing of the levee assured the drowned-out residents of Plaquemines and St. Bernard Parishes that they would receive reparations for their losses. However, many of them, Isleños included, received nothing—nothing for the unnatural loss of their homes, their crops, their livestock, their normalcy or the loss of the 1927–28 trapping season.

Over time, the Isleños recovered from the disastrous Flood of 1927, but since the purposeful destruction of the levee, residents have questioned governments' motives and actions during future crises, especially Hurricanes Betsy and Katrina. Some Isleños affected by the levee break moved temporarily to New Orleans until the waters of the Mississippi River receded, but hardened by countless storms over the years, they returned to the flooded parish to clean out the muck from their homes and rebuild their lives.

Two years and six short months after the high waters, the stock market crashed and sent the entire nation into an immediate downward spiral. The muskrat industry had never fully recovered after the flood, and like everyone else, the Isleños struggled to make a living. The Ford assembly plant in Arabi closed in the early stages of the Depression, and so did Sinclair Oil Company's refinery in Meraux. Wages plummeted, and strikers and strikebreakers created even more friction in an already tense environment. Political corruption still tarnished local justice (once, Leander Perez's investigation of a shooting at a strike that involved several of his known acquaintances led to no charges).[14]

During this time, the Isleños in the Donaldsonville area, near where Valenzuela had once been on Bayou Lafourche, kept closer to their farming roots than their coastal cousins. Most owned small farms that allowed them a sense of self-sufficiency. Others owned large plantation-esque estates, but

these farmers faced greater financial woes during the Depression as they tried to maintain their property. They grew sugar cane, corn, potatoes and peas, and on the weekends the town shuffled eagerly into dance halls to spend time together as a community.

Because they were farther inland, they were less bothered by the yearly harassment of hurricanes. In the late 1920s and 1930s, the Isleños near Bayou Lafourche did have to deal with a few storms, but life went on. Families grew larger; some children moved away to cities such as Baton Rouge in search of opportunity that they could not find on the farm. Education systems, like those in St. Bernard, improved, and student enrollment and participation increased. More young Isleños began to graduate, and some went on to receive degrees in higher education, even law.

In June 1926, shortly before the Trappers' War, the Isleños in Delacroix Island approached the St. Bernard Police Jury and petitioned for a bridge to connect their home to the rest of the parish and to ease the journey of their children to the school building:

> *We, the undersigned residents of De la Croix Island, living on the opposite side of Bayou Terre aux Beoufs from the Public Road, are much inconvenienced by the absence of a bridge to reach our homes, this absence of a bridge also prevents our children from attending school whenever the weather is inclement, as they have to cross the Bayou in pirogues and therefore endanger their lives.*
>
> *In view of the above facts we respectfully requests the Honorable Police Jury to supply us with the material to construct a bridge over the Bayou at a place designated by the Jury and we the undersigned will furnish the labor and at once proceed to erect said bridge in a workmanlike manner upon receipt of said necessary material.*

The letter shows a time when the price for education was more than school books and tuition costs. After some discussion, the police jury decided to grant the materials to the petitioners in Delacroix. Despite their success, this episode illustrates how the Isleños in the lower reaches of St. Bernard remained caught between two worlds, modernity and tradition. They wanted to provide education for their children, but unwilling or unable to move away from the island, they struggled to balance these two worlds because they could not fully exist in one or the other.

Stuck in the rut of the Great Depression and trapped between the old world and the new, the Isleños should have guessed that change was coming. Farms and fishing were not as lucrative; more young Isleños were getting educated, escaping traditional trades and moving away from familial ties for jobs and adventure. And, sure enough, change came. Circumstances began to improve with federal work programs and New Deal legislation, and before long the Isleños stood on the brink of the one event that would change their lives more significantly than any other catalyst up to that point: World War II.

Across an ocean the Isleños had once crossed themselves, brave men stormed a beach at Normandy, innocent people hid in attics and secret rooms to escape punishment for crimes they did not commit and thousands upon thousands of planes, boats, submarines and tanks mutilated the beautiful landscape of Europe and turned it all into an endless battlefield. The Isleños were part of the great battle, both on the frontlines and on the homefront. When the United States entered World War II after the Japanese attack on Pearl Harbor, the life that the Isleños had known for nearly two hundred years vanished abruptly into the wartime machine and never fully reemerged from the cogs. Besides Hurricane Katrina more than a century later, nothing would so dramatically affect the Isleños than World War II.

Dorothy Benge knows this better than most. As a young girl, she watched the world change.

"So how did World War II change things for the Isleños?" I ask her.

She purses her lips slightly before answering. "Some of them went to war in World War I, but they came back to Delacroix Island. My grandfather's brother was one of them. But World War II lasted longer, and they went farther, and they got a taste of the outside world, so to speak. Some married people from other places." She smiles. "You know how soldiers do!"

Like in World War I, young Isleño men, such as Vernon Acosta from Bayou Lafourche and Paul Hernandez from Toca, joined the military for a different life, but even those who stayed home were able to help the war effort. Andrew Higgins, a native Nebraskan with a plant called Higgins Industries in New Orleans, invented a new boat design that would allow soldiers to more efficiently land and disembark, forever improving the ease of amphibian-style fighting. The ramp-bowed front provided soldiers with cover until the boats reached shore. Soldiers no longer had to disembark over the sides, assailed by gunfire, like before. Quickly, motivated by the need

Isleños who served in World War I and World War II returned with a changed perception that altered the future of the Canary Island descendants.

for steady work and the desire to help American forces, the Isleños turned to Higgins's factories in the city.

"They went to work for Higgins and different places," Benge says with a tone of nostalgia. "They went to work outside the parish."

Others balanced steady work in the city with the traditions of trapping and trawling during their respective seasons. Regardless of where they worked, however, a sense of foreignness had crept stealthily and deeply rooted itself past parish lines.

When they returned after a hard-earned victory, the Isleño soldiers went back to their old occupations on farms and in the marsh, but things were not the same. Din wrote that "many of the former servicemen from rural areas, having traveled to distant parts of the world, now rejected the drudgery and isolation of farm life…If the Canary Islander communities somehow retained some of their identity in 1945, the postwar era soon hastened their demise. Isolation was a trait of the past."[15]

The greatest asset in preserving Isleño tradition—their isolation—was gone. The world had shrunk again during the war, and suddenly the big

The center of the St. Bernard Catholic Cemetery is actually a memorial to honor those local men who fought as soldiers in the world wars.

cities, New Orleans and Baton Rouge, were not so far, and the entire country was open to and waiting for them. Assimilation into American culture was now, for the first time, a reality.

"A lot of them came back, but they came back speaking more English," Benge says with a frown. "They were no longer strictly farmers, fishermen, hunters. They had skills now, marketable skills now that they could use."

And use them they did. Isleños took jobs outside of the parish and began to wear blue collars more frequently than shrimp boots. They spent more time getting educated, and they married outside of the Isleño families.

The Trappers' War in 1926 had introduced the Isleños to a life beyond fishing and trapping, but World War II opened their eyes to a whole world outside of the marsh, out of the parish and far beyond the country. Even though many Isleños came back to Louisiana after the war, the tradition of the once isolated people had dissolved. The invading oil industry offered new jobs to the people of southeast Louisiana, and many Isleños began working in the refineries that provided steadier work than they could find out on the open water.

Then, on September 9, 1965, disaster struck again. Hurricane Betsy, a category-four storm, made landfall in southeast Louisiana. The storm had formed near the Windward Islands a few days before and moved into the warm Gulf of Mexico, where it brewed and spun up almost to category-five standards. By the time Betsy hit the coast at Grand Isle, it was a powerful category-three hurricane that tore down houses, ripped apart trees and surged water up the Mississippi toward St. Bernard and New Orleans.

On Friday, August 27, 1965, reconnaissance flights encountered a tropical depression near Barbados. Within days, the storm had turned into a hurricane. After passing over the Florida Keys, Betsy reached Louisiana.

"Hurricane Betsy—September 9, 1965," Benge remembers. "Terrible hurricane, worst we'd ever had."

"What was it like?" I ask.

"There was flooding in the parish. Well, there was always flooding in the lower parish, but this time, there was flooding in Arabi and the upper parish."

Levees buckled and waters rushed in. High winds clocked at more than one hundred miles per hour tore apart houses. In Pointe-a-la-Hache, floodwaters rose to more than fourteen feet. Thousands of people in the parish, New Orleans and the surrounding areas hurried to the safety of shelters.

"Where were you for the storm?" I ask.

Benge leans back against the sofa. "I happened to be at my grandparents' house on Esplanade Avenue at the time. My cousin and his family, they stayed in their houses, as Isleños are apt to do." She smiles again. "Always with a boat," she adds, "which is smart. Otherwise a lot of them wouldn't be here today!"

"What happened?" I ask.

"They had to leave their house and go to St. John Vianney school," Benge explains. "He said it was a terrible experience. The flooding came, and the sewage systems backed up, and they were standing in raw sewage up to their necks in that school. It was awful."

Billion-dollar Betsy and her tidal surge destroyed most of St. Bernard and Plaquemines Parishes. Homes in Delacroix Island were swept away without a trace left behind.

"And then?" I ask.

"He got his family out and took them over to the Domino's Sugar Refinery. And then he came to my grandmother's house—he got there somehow—and cleaned up and he went back with his boat, and he went about rescuing people as they do when it floods."

In the after-action report issued by the Army Corps of Engineers in July 1966, Betsy was dubbed "the most destructive on record to hit the Louisiana coast."[16] The hurricane flooded more than five thousand square miles of Louisiana land, and the report stated that the storm left eighty-one people dead and more than seventeen thousand injured in Louisiana alone.

"Betsy was just devastating to the parish," Benge concludes grimly. "We thought that when Betsy came that that was the worse that would ever happen—until Katrina came."

The same year as Betsy, the Army Corps of Engineers neared completion of the Mississippi River Gulf Outlet, a sixty-mile channel that passed Lake Borgne and connected the Gulf of Mexico and the Port of New Orleans via the Intracoastal Waterway. Authorized by Congress in 1956, the city business leaders and government officials encouraged the creation of the Gulf outlet in the hopes that it would boost commerce and facilitate maritime travel from the Gulf to the port by eliminating the need to travel past the twists and turns of the Mississippi River. However, as people realized with either common sense or hindsight, the side effects greatly surpassed any good the Gulf outlet might have done.

When my grandparents took a picture of the *Del Sud*, the very first ship to use the Gulf outlet in 1963, the channel was six hundred feet wide. By 1989, MRGO's width had tripled, destroying tens of thousands of acres of marshland and leaving the coastal towns even more vulnerable than before. According to a brochure from the sponsors of the Coastal Wetlands Planning, Protection and Restoration Act, a piece of federal legislation passed in 1990 to help preserve Louisiana's fading coast, "The New Orleans district of the U.S. Corps of Engineers speculates that the loss of land in the area approaches nearly 3,400 acres of fresh/intermediate marsh. More than 10,300 acres of brackish marsh, 4,200 acres of saline marsh, and 1,500 acres of cypress swamps and levee forests have been destroyed or severely altered."[17] Not so affectionately called Mr. Go, the MRGO never enticed the high traffic for which the Corps and city corporations hoped. Instead, for more than fifty years, the channel eroded marshlands, altered salinity and, without the buffer zone of the marsh, made it easier for hurricanes to wreak more destruction upon landfall.

Dredging of the MRGO officially ended in 1968. According to the website maintained by the committee sponsoring CWPPRA, the area has lost about 113,300 acres over the last sixty years. Currently, an acre is lost every thirty-

eight minutes, and Louisiana has already lost enough marshland to fill the state of Delaware. These losses, which in turn lead to more losses of wildlife and property and culture, are largely due to the creation of the Gulf outlet, which did not close until 2009—fifty years since its construction began.

When Gilbert Din published his book on the Isleños in 1988, he wrote that Delacroix Island "has never recovered from Hurricane Betsy, and not all of the people have rebuilt their homes…But while bowing to nature, many of the Isleños have been critical of the United States Army Corps of Engineers and the state conservation authorities."[18] Rather remarkably, not much has changed.

CHAPTER 4
INTO THE MARSHLANDS

The first Canary Islanders arrived in the marsh, swamp and soggy ground of Louisiana as farmers, and for centuries after their arrival, the majority of their descendants remained working in those fields. The popular image of trappers and fishermen in southeast Louisiana, in part promulgated by the Isleños themselves, is a fairly recent one because the Isleños were farmers in the mountains they came from and farmers here. However, there is no denying that in that shift, in their journey to the New World, their sense of environment was radically and forever transformed.

Whether as farmers or fishermen, the Isleños have been inseparably connected to the nature around them. Their history is linked to the history of their environment. Hurricanes and floods ruined their fields; the nutrients of the alluvial plain encouraged the growth of their crops. The state of the Isleños is, in part, subject to their natural surroundings.

The Spanish government transferred the Canary Islanders to colonial Louisiana not only to populate and defend the newly acquired territory but also to provide food and crops for New Orleans. No administrative leaders aptly foresaw the problems the immigrants would have in ensuring their own survival, and for years the Isleño farmers depended on rations from the city. Once the willingness to provide this aid ebbed, and the Spanish reign over Louisiana ended at the turn of the nineteenth century, the Isleños were on their own. For one hundred years, the Isleños went on working their small farms in St. Bernard and Valenzuela. The Spanish supplemented their income and family provisions with game and fish, but they remained, as they had arrived, predominantly farmers.

This all changed in the second half of the nineteenth century. In the aftermath of the Civil War, as the dawn of the twentieth century loomed ahead, the Isleños experienced a shift that began to transform them from farmers into the fishermen they are known as today. Union troops and the damage dealt by battles on their land ravaged their fields, especially those near Valenzuela. After the war, the Isleño way of life began to change. Many returned to farming and supplied the city with the meat and food goods that made New Orleans cuisine in the early twentieth century so famous.[1] Others, however, with their fields destroyed and the postwar economy keeping them down, turned to the marsh that surrounded them.

No doubt some Canary Islanders had turned to the marsh for their living well before this moment, but after the Civil War and in the decades leading up to the twentieth century, more Isleños left their small farms and went into the prairie grass as trappers, hunters and fishermen. This industry had grown so much and become so integral to Isleño existence as part of their culture and as a source of income that they were willing to grab their guns and die for it in the Trappers' War of 1926.

Today the Isleños of Delacroix Island, considered the traditional center for those of Canary Island descent, still make their livings on the water and in the prairie grass. Yet the fishing industry has never been without its share of problems. Mussels began growing on the oyster beds, and most recently, the 2010 *Deepwater Horizon* oil spill in the Gulf of Mexico upset the industry, not only affecting the season's income for the Isleño fishermen and shrimpers still working post-Katrina in Delacroix and other parts of St. Bernard but also causing a ripple effect, ramifications that involved seafood restaurants, boat launches and the oil industry on which the Louisiana economy is largely dependent.

Nevertheless, fishing and trapping has been and always will be a part of the definition of Isleño identity, as long as that may last.

Once upon a time, Harry Borden would wake up before dawn. In the morning darkness, before the sun rose and rays of yellow light spread across the deck, he would ready the nets and prepare for another day surrounded by Lake Borgne on all sides of his father's boat, the *Lisa Harry*. Already sweating from the summer heat, before the sunlight began to spill over the distant horizon, he would throw his first trawl of the day.

Harry, an Isleño on both his mother's and father's sides, grew up fishing and trawling in Hopedale. For years, he trawled with his father and his cousins and made a living out on the water.

"What was it like down here?" I ask him. I am meeting him at his home in St. Bernard, which is far away from the bustle of the upper parish, past streetlights and under the starlight. A golden-colored Chihuahua rests in his lap, and from some room I hear a bird chirping.

"It was pretty good," he says. "They didn't have a lot of people. I think you could probably sit outside by the highway and see, you know, three or four cars passing a day. Everyone was related. Going to school and everything was always with your cousins. They didn't have but a handful of people that you didn't know."

In Hopedale, the water was everything, even at young age.

"Everybody back then was a fisherman—it was fishermen or trappers," he explains. He absently scratches his puppy's ears as the dog drifts asleep. "They would fish in the summer, shrimp and then trap fur in the wintertime unless the fur trapping happened to be sort of bad. Sometimes they would fish oysters or crabs or something else. Every kid that was in school used to trap fur in the wintertime on their breaks. Every kid would get out of school early, they would actually let you out, I think it was a month early—they called it early release—for shrimp season. So that way you could go on the boat with your father."

"What age did kids start helping their dads on the boats?" I ask.

"As far as I can remember back, I did it. I can actually remember the first time I went on a boat with my daddy—I was real young, maybe I want to say ten or twelve at the most—and I remember they woke me up really early in the morning, and I was nervous about going. I said, 'Look, if the weather's bad or anything, you gotta bring me home.' And he said, 'Yeah, *bring me home*.'" Harry laughs. "He was lying to me. But anyway, we went out, and when I got out there, it was just like being at home." He continues:

I got started like that. Going to school and stuff, every kid drew pictures of boats. Every kid designed boats. That's all they did, everybody, that's all they talked about was that. So you know, you had this engrained into you that you were going to do that. That was like your heroes—your uncles, daddies, or grandfathers. Like on my family, my mama's daddy, he owned a shrimp boat, and he shrimped. His son was on a boat and his grandson, which was my first cousin. We were best friends. Then on my daddy's side, the same thing. My grandfather was a crab fisherman and then later on he ended up owning a ship yard. That's all they did. You just had that in you. That's all you were around. There was nothing else,

nothing outside of that little world. Back then, I could not have imagined that there was anything else.

After his father got sick, Harry dropped out of high school to trawl full time. His first run without his father was with his young cousin, who was about twelve at the time. Harry says that he was only about fifteen, and alone on the water the two boys spent three days working the nets before returning home.

The one condition was that his mother demanded he take classes to earn his GED.

Harry vividly remembers what life was like back then:

> *We would always throw the trawl before the sun came up, before daylight, because there was this thing that my daddy—it was true—he'd call it the morning and evening trawl. Right at daylight, you would have more and right at dark you'd have more. Usually in the middle of the day, the heat of the day, it slacks off a little bit. So we would throw the trawl before daylight, and once the nets were in the water, he'd start on the nets and I would fix breakfast or something like that, clean up and then maybe pull the nets, say, eight in the morning or something. That would be the first time we'd pick it up, and then we would clean the shrimp, wash them all real good, ice them down. And then just start the process over again.*
>
> *Then at night, usually, we would pick up right after dark and I would start cleaning the shrimp, and we'd clean up and that, and then we would start going to where we were going to go anchor and I'll be cleaning all the shrimp while he was driving. We'd throw the anchor. By then, maybe we'd have things wrapped up around 9:00, 9:30 that night and have everything iced down. We'd go in and eat and stuff, talk a little while, and maybe go to bed for 10:30. We generally did that say five days out, then we would come in for a day. Maybe stay a day or two longer or a day less, depending on how things were. If we caught really a lot, we would come in maybe two or three days, but if it was just a normal, average-type trip, we would probably stay from five to six days.*
>
> *In general, we'd usually be doing this during the summertime. We didn't have air conditioner, didn't have running water. When you went to bed at night, they had plenty mosquitoes, so you'd have to put the screens up. You also had the engine down there that was hot, still cooling down, so it was pretty hot. Taking a shower was on the back of the boat with a bucket, pouring it over you. We*

had about a 35-gallon garbage can that we bought brand new, and we had that with fresh water in the back the boat. We'd use that for cooking. Today everything's fixed nice, you know. We didn't have all the fancy stuff back then.

Still isolated, the Isleños learned to be self-sufficient out on the water. The fishermen designed their own boats. They made their own nets and repaired their own webbing. In a pinch, they even turned a garden hose into a giant snorkel so men could breathe underwater to fix problems on their boats.

"We had some innovative ideas, man. Ain't no doubt about that!" Harry exclaims with a laugh.

Yet for all the good times and the fun stories he tells me, there were often moments of desperation and worry. The industry is subject to the whims of nature—sometimes the oysters were plentiful, other times their scarcity increased their value. Toward the mid-1990s, however, the freshwater diversion efforts allowed mussels to destroy the oyster beds. With their families depending on this unreliable, uncertain income, many Isleño fishermen held their heads in their hands far too often.

"I remember one year," he says. "It was when they had the First Gulf War because I remember they didn't have hardly any oysters. And I remember this well because my daddy was on his boat by himself, working. He didn't have a deckhand, and I was on the other boat by myself. There wasn't enough for us to have anyone working with us. You'd work all day and maybe make twenty or thirty of these little five-gallon buckets. They didn't have any oysters. I remember that really well because that was right at the time that they started dropping bombs."

Today, even though his life has changed away from his daily routine exclusively on the water, Harry still remembers his roots. His raises crops and takes care of cattle, goats and other livestock. After the storm, he finished his master's in applied physics and is now working toward his PhD in engineering and applied science at the University of New Orleans.

"You know, thinking about it, in the beginning it was really good with my family, and then toward the end there, it got kind of bad financially. As bad as it was, though, looking back at it, they had a lot of good times. I wouldn't trade it for nothing in the world because I learned so much," he says.

His mornings might no longer begin with the smell of salt water or end with the roll of the waves just before falling asleep, but his Isleño heritage and the values he learned by growing up as a fisherman are still very much a part of his everyday life.

"It is a source of pride," Harry says with a slight sigh.

Thinking back of all those generations of people, we talked about this... [he gestures to his son on the sofa]...*about the graveyard at the St. Bernard Cemetery, I was telling him they got people buried that they don't know who they are, but that was Isleños people who came over here. It is a source of pride. Let me tell you, they're also very innovative, very creative and very smart. People think that these people are stupid, but nothing could be further from the truth. I mean, first of all, you have a lot of people who rose to prominence from the Isleño people. But even the ones that you don't know of...there's the great unforeseen mass that exceed those that people know about. Just nobody knows their story.*

After World War II, in arguably the first turning point away from tradition toward modernity for the Isleños, men in St. Bernard began to look for work besides fishing and trapping. Better educated and more worldly by this time, they went into the nearby city for jobs. Others flocked to the steady work schedule of the oil and natural gas refineries.

In this process, they grew less dependent on the marsh for their income, and the Isleños turned to the water for recreation. They built camps along the canals in lower St. Bernard Parish and in the Violet Canal. There they went on weekends, holidays and their free days to fish and trawl for pleasure rather than subsistence living. There they swam in the water and hunted in the prairie. Annual boat blessings blended their regard for faith and fishing. For the Fourth of July, camp owners in the Violet Canal piled into their boats for a parade that weaved through Happiness and Horseshoe Canals and had an annual water balloon fight with those left on the wharves of the camps. The older generation taught their children, their nieces and nephews an appreciation for and an understanding of nature, and even though their life was no longer "do or die," they still stayed in tune with the daily existence of their ancestors. By doing this, they managed to delay the degradation of their culture for another few and precious decades.

Just beyond the ship channel, Martello's Castle, a fort built around the crisis in 1812, once jutted out of the water like a beacon. The brick fort, a relic of the past, has been used in the second half of the twentieth century as a camp for the family of Merrill Perez. Now surrounded by waves on all sides, it is more than a little eerie to realize that when it was built two hundred years ago, it was built on land. Over the years, the fort became a symbol, a

Martello's Castle, constructed as a fort in the early 1800s, survived storms for nearly two hundred years before collapsing to the winds and waves of Hurricane Katrina.

The fishing camps in the canals were once one of the last ways that many Isleños remained connected to the water on a regular basis, but their destruction in 2005 has left Isleño culture even more fractured than ever before.

testament to the lives those generations of Isleños had there. But in 2005, the fort—the same structure that survived a war, Betsy, wicked waves and an era before hurricanes even had names—surrendered to Hurricane Katrina.

They know what they miss: the salty spray of a wave before a thunderstorm, the feel of a cool breeze and a warm wharf and the sweet sway of the hammock that rocks back and forth between sunlight and shade. The Violet Canal and the other waterways like it served one useful and essential purpose: they kept the post–World War II generations of Isleños participating in the activities of their ancestors. Out on the water there, they shrimped and trawled; they fished all day long in the inlets of the marsh that their daddies taught them, that their grandpas once taught their daddies even before that. In their boats, they always waved to whomever they passed

in the canals, whether they knew the people or not. And they always waved back. Whole generations grew up together running barefoot on the rocks and swimming in Marunga, the shallow water. On the water, where sound carried, the scent of a barbecue spread and the glow of a porch light could be seen for miles, it is easy to foster a sense of community.

But the marsh is fading. After half a century's worth of damage levied by the Mississippi River Gulf Outlet, the erosion by every wave of a passing boat, the hurricanes and simply time itself, the marsh grass is being lost every day. According to the Coalition to Restore Coastal Louisiana, "[C]oastal Louisiana has lost an average of 34 square miles of land, primarily marsh, per year for the last 50 years. From 1932 to 2000, Coastal Louisiana lost 1900 square miles of land, roughly an area the size of Delaware."[2] In 2003, the U.S. Geological Survey predicted that "if present trends continue, the state will have lost 2,400 square miles of land between 1932 and 2050."[3] This is just yet another battle for those people who live on the Gulf Coast.

Efforts are being made to save the coast and, vicariously with it, the Isleño way of life. Organizations such as the coalition donate money to preserve the receding coastline. America's Wetland Foundation, which launched its Campaign to Save Coastal Louisiana in August 2002, even features a ticker on its website, tracking the estimated real-time loss of marsh down to the second.[4] The state government of Louisiana has created the Coastal Protection & Restoration Authority to oversee coastal wetlands conservation and restoration.[5] Everyone, it seems, is doing their share. In 2010, Abita Beer even brewed a new beer called S-O-S, "Save Our Shores," to help restore the coastline.[6]

Sherwood "Chief" Gagliano and his son, Mark Gagliano, invented reef blocks, live oyster panels that prevent future erosion and rebuild the lost environment. Already implemented in parts of Texas, their ReefBLK system has been featured on television segments, books about Louisiana and articles about the problems the Gulf Coast faces in saving itself.[7] Their innovation has led to success. WDSU reported that in Matagorda, Texas, the erosion process had reversed and land was returning.[8] The oyster baskets placed along the shoreline allow silt to be deposited instead of washed away. With the silt, the ground can rebuild, and with the ground, the marsh grass can regrow. Birds can return, fish can live, oysters can thrive and the coast can be saved.

CHAPTER 5
EXPRESSIONS
ISLEÑO CULTURE

The Isleño identity is defined largely by four things. The first is their common history. Whether they settled in Valenzuela or St. Bernard, all of the Canary Island descendants were brought over for the reason of populating and defending Spanish Louisiana; all of them dealt with sickness and hurricanes, planted their crops and gradually became increasingly involved with modernity. The second is their connection to the environment. The Isleños learned the land as farmers, and then they learned the marsh as trappers and fishermen. Every hurricane reinforces their bond to the natural world, one they can never fully control. The third aspect of Isleño identity is their community. This tightknit small-town mentality and closeness of extended family has developed after centuries of isolation and dependency on familial ties.

The fourth of these attributes is their culture. The Isleños have their own Spanish dialect, food recipes, music, folk medicine and art. They make detailed and beautiful Tenerife lace patterns. They sing stories passed down from generation to generation. They cook, they heal, they carve and they draw. And in each of these tasks, the acknowledgement of their heritage, conscious or not, adds a distinct Isleño flair.

Even though most men and women of Canary Island descent only know the word "Isleños," and not what it truly means (if they know the term at all), bits and pieces of Isleño identity manifest in their daily lives. In a children's playground in St. Bernard Parish, a man and a woman in traditional Isleño dress have been painted on the equipment. Tourism signs flaunt the word near Galveztown and across St. Bernard. Similarly, in San Antonio, a mural

in the Space Needle details the path the city's own Canary Islanders took to reach Spanish Texas. Unknown and often invisible, the reminders of the Isleños turn up in the oddest places.

Over the years, Cecile Robin, a member of the Los Isleños Society, has compiled the best Isleños folk remedies into a booklet sold at the festivals. She lists cures for just about anything, from removing hives to clotting gashes. Of course, the Isleños wisely depend on a doctor more than most of the folk medicine, but a few of these home fixes continue to persist. Some still insist that putting an onion beneath a feverish person's feet will burn out the fever. Most of these, however, remain in stories and family traditions for nostalgia of the way things used to be done in the past.

The Isleños have exhibited their recipes in cooking demonstrations at local festivals, and the Los Isleños Fiesta advertises the authentic Spanish

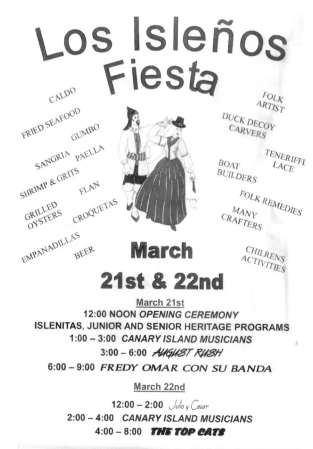

Los Isleños Fiesta

CALDO
FRIED SEAFOOD
GUMBO
SANGRIA PAELLA
SHRIMP & GRITS
FLAN
GRILLED OYSTERS CROQUETAS
EMPANADILLAS BEER

FOLK ARTIST
DUCK DECOY CARVERS
TENERIFFE LACE
BOAT BUILDERS
FOLK REMEDIES
MANY CRAFTERS
CHILRENS ACTIVITIES

March 21st & 22nd

March 21st
12:00 NOON OPENING CEREMONY
ISLENITAS, JUNIOR AND SENIOR HERITAGE PROGRAMS
1:00 – 3:00 CANARY ISLAND MUSICIANS
3:00 – 6:00 AUGUST RUSH
6:00 – 9:00 FREDY OMAR CON SU BANDA

March 22nd
12:00 – 2:00 Julio y Cesar
2:00 – 4:00 CANARY ISLAND MUSICIANS
4:00 – 8:00 THE TOP CATS

The annual Los Isleños Fiesta allows researchers, craftspeople, historians and cultural enthusiasts to celebrate their common interests and raise awareness of local Spanish customs. *Courtesy of the Los Isleños Heritage and Cultural Society.*

cooking on its posters every year. From caldo to sangria, men and women crowd the food booths every festival to taste these Isleño dishes. Local Isleños even gathered their family recipes in *The Los Isleños Cookbook*.

At festivals and other special occasions, men and women don traditional Isleño dress. Women wear bright colored, striped skirts and crisp white blouses with lace accents. Scarves fit under their straw hats to protect against the wind. Men wear vests over their shirts and hats to ward away the glare from the sun. Burt Esteves and Dorothy Benge of the Los Isleños Society have their own custom-made clothing from the Canary Islands, and the society has donated Isleño outfits to the local schools for students to use when they serve as tour guides at the annual Battle of New Orleans reenactments. Details in clothing styles, such as the types of hats, differ from island to island and village to village, but in St. Bernard they blend

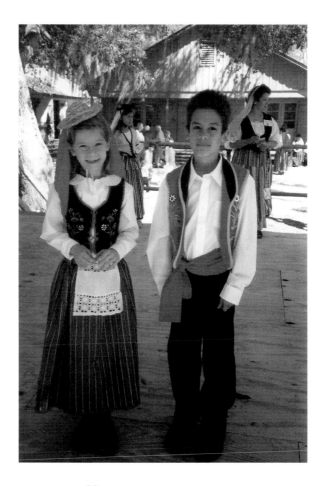

Children dressed in traditional Isleño clothing. *Courtesy of Dorothy Benge.*

these styles, the colors and the designs to express the uniqueness and also the unity of Isleño culture.

These parts of culture define Isleño tradition. They are, in part, what the local culture groups and the researchers fight to preserve, document and protect. Some have been lost—only a few still speak the Isleño dialect of Spanish and only a few hands are still able to knit the intricate Tenerife lace—but other traditions, although faded, still remain even today in these Isleño communities.

DÉCIMAS

One of the most notable and easily recognizable expressions of Isleño identity is the singing of Spanish *décimas*, or a cappella folk songs. These folk songs originated in medieval Spain and came to the Canary Islands during their conquest during that same period. They came to Louisiana in turn through the Isleños in the late eighteenth century. The Isleños, already so dependent on oral tradition, used these songs to pass their stories to the

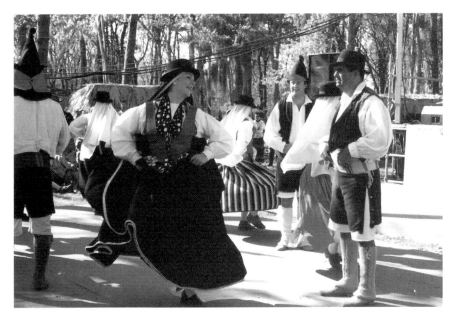

Canary Island dance troupes entertain at the Los Isleños Fiesta. *Courtesy of Dorothy Benge.*

next generation. In "The Last of the Louisiana Décimas," Patricia Manning Lestrade described the traditional songs as "poems of ten octosyllabic verses" that survived in the popular Isleño dance halls.[1] Through the popularity of these dance halls, the *décimas* survived.

Although the art of singing *décimas* has declined considerably in the twentieth century, cultural leader Irvan Perez from Delacroix Island brought the songs world recognition. As he became involved in the Canary Islands Descendants' Association, he revived the songs, recorded his work for posterity and proved to others that Isleño culture in Louisiana was still very much alive. During his career as a singer, he performed at local festivals, at Washington, D.C., at the Canary Islands and at Carnegie Hall. His death in 2008 was a hard loss for the Isleños. However, because of his talent, his pride in his past and his warm and welcoming personality and enthusiasm, Irvan Perez became a legend.

To better understand Perez and his contributions to Isleño music, I meet with his daughter, Carol Nunez.

"How did your dad grow up? Was he involved in Isleño culture?" I ask.

"We grew up in Delacroix Island," she tells me. "We lived with my grandparents on my father's side. I lived there until I graduated from high school, and then my mom and dad moved here to St. Bernard. As a boy, my dad started carving very early and started singing *décimas* very early. Later on, he also wrote a few *décimas*, just as my grandfather had."

In addition to being a cultural leader in the parish and a singer, Irvan also turned the skill of woodcarving into an art. Some of his decoys even have been displayed in exhibits at the Smithsonian.[2]

"And my grandfather—I have a dominant memory of him, my dad's dad. Because, it seemed like he was home and my dad was out on the boat, either trawling or fishing. But I think the reason I remember my grandfather was because he played cards with me all the time, and he also played a guitar and he sang. I remember him singing."

"Your grandpa sang the *décimas* too?" I ask.

"Yeah. I didn't know they were *décimas*. I couldn't have said the word *décimas* until my dad got involved in it, but I knew that he sang in Spanish and in English, too—he sang in both. I don't recall what he sang, and I didn't know that they were *décimas*. My grandfather was regarded by everyone as having a phenomenal memory. I remember daddy saying he couldn't read or write, but he could remember patterns in his head," she says.

Memory is vital to *décimas*, which function as stories of the past and the present. Irvan's tenor voice and vibrato captured stories passed down

for generations and some original others that he made up during his own career. From a crab fisherman who got attacked by bees to a Spanish woman waiting for years for her husband to return from war, Irvan sang about it all. His song about the Trappers' War describes the events and sentiments leading up to the conflict:

LA GUERRA DE LOS TEJANOS

Ahora ponga atención
Lo que yo le voy a canta
Cada vez que me cuerdo quel día
Me dan gana de llorá.

De la guerra de lo tejano
Cuando vinieron a guerreá
A la ihla de San Bernardo
A varios se le ha olvidado
Pero a mí no se me olvidó.

El que tuvo la culpa de todo
De ehto eran Perez y Meró.
Nojotros ganamo la piería,
Se la entregamo a Manuel Molero
Pero no cumplió con la gente
Puso mucho extrangero.
Ha arruinado todo lo que había.
Por a causa de Manuel Molero
Lo poquito que quedaba
A Adán Sardín
Se lo dio a loh extrangero.

[…]

Y con esto yo no canto má
De la guerra de lo tejano.
Si la cosa no se cambea
Adió la Isla de San Bernardo.

THE TRAPPERS' WAR

Now pay attention
What I'm going to sing to you
Each time I remember that day
I feel like crying.

Of the war of the Texans
When they came to fight
To the island of St. Bernard
Many have forgotten
But I haven't forgotten.

The one who was to blame for all
Of this were Perez and Mero.
We won the marshland,
We gave it over to Manuel Molero
But he didn't keep his promise to the people
He put many foreigners
He has ruined everything that was.
Because of Manuel Molero
The little that remained
To Adam Sardín
He gave it to the foreigners.

[...]

And with this I won't sing anymore
About the war of the Texans.
If the thing doesn't change
Good-bye Island of St. Bernard.[3]

The lyrics capture the importance of memory, as well as the events of the crisis. The Isleños, whose culture has survived almost exclusively thanks to oral tradition, used *décimas* such as this one to teach future generations of their history but also to pass on the moral of the story, the life lesson that they realized and have now passed on for others to learn from.

"One of the strongest features about my dad was how much he just had a reverence for his father and his mother," Carol continues. "My dad always had this way—everybody kind of looked after him. My dad had this ability that people really liked him."

This reverence remains in Carol's own memories of her family and her own stories that she shares.

> *I remember one time he built a pirogue, and it was under our house—the house was elevated. I recall my dad telling us, "Be sure not to touch it. Be sure not to play with it" because he had just put it together. I remember getting caught sitting in the pirogue—they walked around the house and there I was, sitting in the pirogue! I remember my dad taking me out, however old I was, and swatting me on my behind and then locking me in the shed because I was arguing, "I wasn't hurting it! I was just sitting—I hadn't moved or anything!" That made him madder and madder, and they put me in the garage, and they locked it. I couldn't see out—the window was high—so I stood on a heater, and I was jumping up to be able to see outside, and I fell and hit the gas, so the gas was coming out! So what I did was—I broke the window!...[She starts laughing.]...I remember my dad was furious, but my grandpa kind of had a little twinkle in his eye. From then on, I always thought he was my protector.*

"So your dad was a fisherman growing up?" I ask.

She nods and hands me a picture of Irvan. He looks happy, gray and middle-aged but still healthy, surrounded by green outdoors. "This is my father," she says. "This picture was taken after the storm, almost right before he died. He died when he was eighty-five."

"He does *not* look eighty-five," I say.

"I know! My mother was so proud of the fact that daddy was young-looking. Once in college, there was a dance my freshman year, and I had no one to go with. I didn't know anyone, but I wanted to go. Alan [she gestures to her husband, who is sitting on the sofa] was in the service. And my dad brought me, and everyone thought he was my boyfriend." She grins.

"Mama wanted daddy to quit trawling. She didn't think it was secure, and she wanted him to quit, and he did. He worked at Kaiser, so they kind of got away from trawling and hunting. They still did it, but…."

"But it was for fun, from the heart, rather than to put food on the table," I finish. "When did your dad start to get so involved with the *décimas*?"

"I think when they started the Isleños club," she says. "There was revived interest in preserving the culture. So when he got involved in the club and they started promoting him because he could speak Spanish and because he could sing the *décimas* and because he had a love for his culture, there was nothing that they would ask him to do that he wouldn't do. That's when daddy got back to the *décimas*."

Although he performed numerous times across his hometown and across the country, the Canary Islands were always a special place for Irvan. "Daddy was a celebrity there," Carol says, "so he had a lot of interviews. We went to see the various government officials. Just as everyone else who's been to the Canary Islands seems to say and I absolutely agree, the people that we met reminded us of the people we knew in Violet. You could see characteristics; we felt very comfortable there. There were just a lot of things that reminded us of growing up at the island."

"Can you remember any major points in your dad's career as a *décimas* singer?" I ask.

"He sang at Carnegie Hall," she tells me proudly. "He participated after that in every folk life festival he was invited to because that whole revival started at that time. I did go to D.C. for a folk life festival and stayed two weeks. He performed at the festival. My mom demonstrated Isleño cooking."

"What do you think the songs meant to him?" I ask.

"Well, I think they always symbolized his love for his father and family and his past," she muses.

Whatever the emotional value the songs had for him, the parish had those same feelings for Irvan himself. The man was an icon, a cultural leader, who managed to balance the songs of the past with never-relenting efforts to educate others for the future.

LANGUAGE

Fairly recent scholarship concerning the Isleños has focused on their distinct dialect of the Spanish language. In 1990, linguist John Lipski published *The Language of the Isleños: Vestigial Spanish in Louisiana*, an in-depth look at the Isleño dialect of Spanish. This adaption of traditional Spanish has become, as he dubs, "the least known, most unique, and linguistically most significant."[4] Lipski recognizes that the remoteness of the region allowed Spanish to persist in St. Bernard, and the melting pot effect of New Orleans openly allowed

Spanish, French and Italian to linger among and sometimes even dominate the English. Although the dialect has its roots in Canary Island Spanish, its proximity to English, however, altered the syntax of the language over time—subjects of sentences were used with infinitives, morphology changed and the use of pronounces shifted. The existence of Isleño Spanish, Lipski wagers, hints at more complex sociolinguistic questions.

Today, the Isleño dialect, like so many other parts of their culture, is almost extinct. Only a few of the elders still speak Spanish, and the insurgence of the Latino population after Hurricane Katrina has restored some Spanish to St. Bernard Parish, but their Spanish and the Spanish that young Isleño boys and girls learn in classrooms are not the same as the Isleño dialect. With so few teachers remaining to pass their unique version on, and so few students willing to learn, time is of the essence. If the next generation of Isleños wants to learn their ancestors' dialect, or if the cultural groups want to better document and record the language, they must do so quickly before it is forever too late.

CHURCH

As the festivities of the annual Los Isleños Fiesta go on outside, I meet with William de Marigny Hyland, the St. Bernard parish historian, in one of the period homes re-created by the parish's active cultural society. Hyland is one of those amazing men who knows a lot about everything, whether it is which ship your Canarian ancestor stepped off two hundred years ago, navigating through the genealogical family bush that constitutes the main St. Bernard families or giving tours to museum visitors on the long history of the area's Isleños.

"Can you tell me about the early buildings in the St. Bernard colony?" I ask him.

"Well," Hyland starts, "the first structures that were built in St. Bernard Parish—and we know this from records in the St. Bernard Parish clerk of courts office and also from records in the Louisiana State Museum in the Cabildo, records in the New Orleans notarial archives and the documentation available from through the Archives de Indias in Seville, Spain. We know that the very first buildings which the Canarians built were temporary, and they were what the French called *poteaux en terre*, meaning 'posts in earth.' The posts were driven into the earth, and then they either in-filled the area between the

The Los Isleños Society has re-created and restored period homes donated to the museum by Isleño members of the community.

posts with a substance called *bousillage*, which is mud and moss and animal air, or they just covered the walls with planks, planks of cypress. The roofs were also of wooden shingles. So it was a very primitive house style."

"When did they begin to get more permanent houses?" I ask.

"In the 1780s," Hyland answers. "The Spanish government began to fulfill the promise of building permanent houses for the Canary Islanders. Those houses measured largely by twelve feet by twenty-six or twenty-five, two rooms each, with a gallery in the front and back, with a gabled roof. And we have one of the houses here—the Estopinal house, which lost its roof during Hurricane Katrina."

Since the storm, Hyland has worked with parish officials, the Los Isleños Heritage and Cultural Society, contractors, construction workers and Federal Emergency Management Agency (FEMA) to refashion the buildings lost during Hurricane Katrina. The process has not been easy, and for every advancement made, the project has suffered setbacks, hang-ups and mistakes. Still, Hyland keeps working toward finishing the museum and restoring it to what it used to be.

St. Bernard Catholic Church was originally built in the 1780s. After several reconstructions, the current building serves as a religious center for residents in lower St. Bernard Parish.

"What about the St. Bernard Church?" I ask.

Hyland waves to a few people he knows who are passing through the house, but then he turns back to me with a smile. "The first St. Bernard Church was also begun in 1785. St. Bernard Church was the first ecclesiastical parish established below New Orleans, and the first church was completed in 1792. It was also built by François deLery, and it was of posts and *bousillage*. And the building had a gallery on three sides, and it had a belfry in the center," he says as his hands sketch the church's design in the air, "and that church remained in use from 1792 to 1852."

From the very beginning, gaining permission and actually establishing churches in the Canarian settlement areas was extremely important. In Valenzuela, they fought tooth and nail against the nearby French colony for the right to have a church closer to their homes than the Acadians. In St. Bernard, the colonists insisted on constructing their own church in the 1780s.

"And that church was extremely important," Hyland emphasizes. "The church was positioned to be in the geographic center of the original settlement

of San Bernardo, which became the original parish of St. Bernard, and the church was where all announcements, all edicts of the Spanish government were posted on the doors. All slave manumissions, auction sales. That's where auctions and different public happenings occurred, all public fiestas. The church was the center of this community. Everything centered around that St. Bernard Church."

"And then in 1852," he goes on, "a new St. Bernard Church was built. It burned in 1916 under suspicious circumstances. And then the present St. Bernard Church was built as a mission chapel in 1924."

After being flooded in 2005, the St. Bernard Catholic Church has been rebuilt once again. For the rededication Mass on November 11, 2007, hundreds stuffed the small church, in the choir loft, in the foyer and out the doors onto the porch. Now a plaque hangs beside the door, and the text celebrates the long history of the building, its predecessors and the ecclesiastical parish it represents.

"And then, of course, the St. Bernard cemetery," Hyland adds, "across the bayou from St. Bernard Church, was established in 1787. It's the oldest

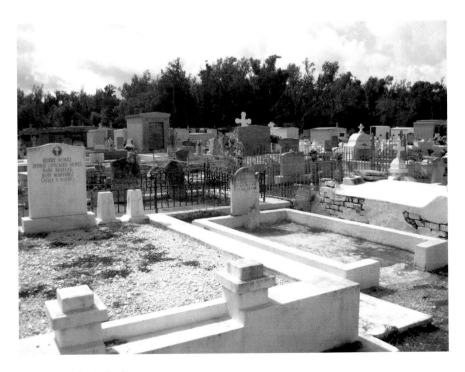

St. Bernard Catholic Cemetery.

cemetery remaining in the Greater New Orleans Area, if you define that area as St. Bernard, New Orleans and Jefferson Parishes."

"What else was there about the early Isleños? Was there anything that really separated them from the other colonists in the area?" I ask.

Hyland waves his land loftily again. "The Canary Islanders from Tenerife particularly brought with them the peculiar of domesticating cattle," he tells me. Out of the window behind him, a group of girls walk past the rusted farm equipment they have on display out there on the grass.

"Cattle? They trained cows?" I ask.

Hyland nods. "There are written accounts in the 1830s of these cattle domesticated in the tradition of Tenerife, bringing the farmers sleeping on hay in ox cars to the French Market without any direction. It was remarkable."

"That's amazing," I reply.

Hyland waves his hands again. "And people came over from Louisiana and eastern Texas to have their cattle trained here in St. Bernard Parish within a mile of this museum complex."

Today, the Isleños do not train cattle for Texans, but the period homes featured at the museum complex and the St. Bernard Church remind visitors of the Spanish influence to the area. The St. Bernard Catholic Church, once built to serve the initial Isleños in Delacroix and the surrounding lands, now holds Mass every week and even celebrates weddings of local couples. Only a few years ago, St. Bernard resident Ryan Fink and his wife held an Isleños-themed wedding, *mantilla* and all, to honor their heritage. So much, like cattle training and the building of palmetto huts, has been lost either from disinterest, discouragement or the lack of necessary use in the face of modernity. However, the continuality of these aspects of their history still work to maintain Isleño culture in the community.

ART

The Isleños, like all other groups across the globe united by common history, have found ways to express themselves and their culture through art. In 2010, Barry Lemoine wrote and directed *The Somewhat True History of St. Bernard (Abridged): A Love Story*, which packed Nunez Community College's theater for three days. Actors hilariously spoofed parish leaders, events and slogans and retold key moments in the area's past, from the Irish, Italian,

Isleños Parade to the Battle of New Orleans, with an actor performing Bill Hyland, the parish historian, as a guide throughout the play.

Charles Robin III, an Isleño from St. Bernard, deftly carves wooden boat models, from sailing vessels to shrimping rigs. He learned the skill from his own father, who lived, shrimped and carved in the lower parish for most of his life. Charles Robin Jr. even had his models on display at the Biloxi Museum and the Madisonville Boat Festival; both father and son have showcased their craft at the New Orleans Jazz and Heritage Festival.[5] In an interview with the *Times-Picayune* back in April 2010, Charles III said that his father was "a master boat-builder. He built these models out of his head. He knew everything down to the T. My daddy didn't have but a fourth-grade education, but he used his hands. That's how he told his stories."[6] These boats are part of Isleño expression of culture and a valuable addition to Louisiana art.

Still other local artists, like Jose Balli, express their Isleño heritage in different ways. Raised in Delacroix Island, Jose grew up with an appreciation for the beauty of nature and a keen understanding of the importance of community and family. The great-nephew of Delacroix legend Blackie Campo and the son of a Morales, Jose grew up surrounded by the presence of the Isleños. Over time, as he developed as a painter and then as a jewelry designer, he began to incorporate these parts of his past into his work, from crab bangles and crawfish earrings to gorgeous and detailed crosses made out of the shape of a flying pelican. He now manages four store locations in the Greater New Orleans area, and his heritage is still very much a part of his life.

It is getting close to mid-morning as I pull into the parking lot of Jose Balli's Covington store and walk to the door. It beeps as I push it open, and Jose emerges from the back of the store to greet me. Cases of jewelry hug the center of the room, and the eyes of Mahalia Jackson and Louis Armstrong hanging on the wall follow me past fleur-de-lis filled with New Orleans and St. Bernard icons.

We settle down at a table in the back office of the store. "So how did you get into art?" I ask him.

"I was in about the second grade. I got my first compliment down in Delacroix that I could draw really well," he remembers. "It was a friend of mine's mom. I forgot what I was sketching, but she said, 'You draw really well!' That was my way of expressing myself. Art was always my first love. I just had one of those artist's spirits. You draw when you don't have anything to do, and you draw when you should be doing something else. I knew I didn't want to be a starving artist," he laughs.

"And jewelry?" I inquire.

"I got my hands on jewelers' wax," he explains, "and that was it. It was a real forgiving medium. If something breaks, I just put it back together. If you over-carve something, you just build it back up and start again."

"How do you think that growing up in Delacroix, the hub of the Isleños, and then in Reggio—how do you think that influenced your art?" I ask.

Well, if you look at my art, it's really nothing but Louisiana. I try to paint from the heart or design jewelry from the heart too. Growing up, my first job was with one of the old fishermen down there. I couldn't have been but maybe eight years old or nine years old. He kind of had a heart condition. Really, the strain of picking up crab traps wasn't good for him, so he recruited me, and I would go before school. I could barely get them out of the water, but I did, and he'd give me a percentage of whatever he made that day. And I'd clean up and go to school. Just looking at what was around me—there's a lot of beauty in it, as kooky as it sounds. I love the colors of blue crabs, the texture of alligators. Crawfish always were neat to me. I grew up crawfishing. It was one of my favorite things to do, in fact. I was just fascinated with the animals, just the beauty. Palmettos—I can remember studying them, the symmetry.

Jose's catalogue features dozens of pieces inspired by his youth in Delacroix Island and then in nearby Reggio. He has designed alligator rings and a simple pelican broach given an elegant touch by three snow-white pearls. Sterling silver cattail stalks weave together to form a ring, and a palmetto fan dangles from a nearby chain. After the oil spill, he even donated 25 percent of everything he made from certain newly designed pieces to the Coalition to Restore Coastal Louisiana and helped rebuild Louisiana's failing coastline.

"Nothing else had the appeal to me as fishing and crawfishing," he says. "Trapping I didn't like. Hunting, it was take it or leave it. Duck hunting to me was misery. Not that I mind shooting a duck—I just could never hit one!"

"And then trapping—it was funny, I tried that." He shakes his head and laughs. "I had a friend who was doing it, and he gave me maybe half a dozen traps. I set my traps out, and the next day, I went back to check them. There was a nutria in one, right? But something had just gotten to it and just chewed it to pieces, and it was a big nutria too—like the size of a German Shepherd it seemed at the time! His *head* was there. His guts were there, *legs* over there. I left every trap back. I said, 'Whatever got a hold of him

isn't catching me!' And I just ran home. Those traps are probably still there rusting. That ended the trapping."

We are both laughing. "I saw that you have a print dedicated to everything St. Bernard," I say.

"The St. Bernard print—that one just kind of developed," he replies. "I did a rough sketch of it, then started painting it. I'm praying the whole time, you know, 'What else can I put in here that represents St. Bernard?' What is somebody going to come up to me and ask? 'Where's the mosquito?' or 'Where's the shrimp boot?' I fit that in there. Just pulling stuff from memory, too, different icons that meant something to me. Of course, shrimp boots—I worked in an oyster factory early on. I wanted to include those things. The boat is the *Mr. Casey*, the boat that my uncles owned that they trawled in."

"I heard you are currently working on a new series specifically on the Isleños?" I ask.

He nods and tells me that he had collected old pictures of the people in Delacroix and is currently re-creating them as paintings on canvas.

"That's the thing about these old pictures—they're hard to find," he says. "A lot of them were lost in the storm. It's hard to find people with the albums, if they survived at all. That was kind of the reason for doing the series—they wouldn't be forgotten. I don't have all the names, but the faces are there. These are people who lived down there, they grew up. They worked, they played. If it weren't for what pictures that are left, they would have no exposure and they would be forgotten."

He pulls out his phone and starts showing me the pictures he is working with for the project. Faces of Isleños scroll past, their eyes searching out for our own. His thumb stops flipping at one.

"This is a great shot, too. He's covered in oil, and he's working on pistons, smoking his cigar." He grins and flips past some more pictures. A group of men are sitting at a bar. "Just eating oysters and drinking beer."

"Do you have dates on these?" I ask.

"Most of these are from the '50s. I wanted a visual history of faces," he says. "If you look at the paintings, the focal point is the face, and as you get away, it loosens up in detail. I wanted people to be drawn by that. I wanted to haunt them in a way. I wanted them to have the memory of these people put in them somehow, and they wouldn't be forgotten."

He pauses at another picture of a young boy with his round face tilted to the side and his wide grin stretching from one ear to the other. He is dressed in overalls without a shirt and barefoot, toes caught almost mid-wiggle, sitting

on sun-warmed porch steps with a puppy in his lap. The boy's face, his joy, is contagious in that amazing way that happiness can spread. "He died as a boy," Jose tells me soberly. "There was a cable or something—he was riding his bike. I don't know, he veered off the road and it cut him, and he passed away." He gestures back to the painting in progress. The little boy is grinning at the camera, holding his puppy. "It's called *Carefree and Innocent*."

Currently, two wall-dominating originals of this series hang in his Metairie store, and the little boy's huge grin welcomes every customer. Like with the *décimas*, memory is integral to Isleño art, and Jose's paintings, especially this one, represent a way of memorializing these figures and their experiences from the past. Knowing the little boy's story somehow makes the painting even more beautiful.

"It's something that really comes from the heart," he says again. "It'll be more than just a photo in somebody's album somewhere."

Isleños like Jose have found ways to express their culture through art, whether through more traditional mediums like paintings and plays or through the construction of boat models. Whatever the outlet, their art, beautiful and unique and tied inseparably to their culture, continues to capture aspects of the Isleños' past.

PASSING IT ON

Maybe the most important thing about Isleño culture, more important than the *décimas* or dishes or dress, is their ability to pass on these traditions to the next generation. Continuity has been integral to the Isleños' survival since their arrival. That is why disheartened, frustrated fishermen stressed the potential loss of culture at council meetings after the oil spill, and that is why the Isleño cultural organizations have worked hard to re-create parts of the past. And that dedication to passing on culture, history and materials to the next generation is what Lorraine McDaniel's house in St. Bernard Parish represents.

It is storming as I hurry onto the porch and knock on Lorraine's door. She opens the door, gives me a quick hug and ushers me inside as the thunder cackles. We sit down in her living room, and the muted TV spills light into the room.

"Did you always know you were Isleños?" I ask her.

She shakes her head. "I didn't know I was Isleños," she admits. "My grandmother always said they were French because people were ashamed

of being Spanish. You know, back in the '50s, they used to punish you if you spoke Spanish. So because my grandmother always said they were French. But I mean, they were Canarians. Pure Spanish."

"So how did you find out that your family was Spanish?" I ask.

She laughs. "I dated this guy from New Zealand—this was twenty years ago—and he started telling me, he goes, 'You're Isleño.' And I said, 'What the heck's that?' He said, 'Your family's Spanish!' So we went to the Isleños museum."

From there, she began to research her family, discovered her Spanish roots, traced her Canary Island heritage back to Gran Canaria and Tenerife and became increasingly involved in the Los Isleños Society. Now she has been a board member for fifteen years. Lorraine helps design and create the souvenirs, T-shirts and aprons sold at the museum and at the local festivals, and she works to organize various events that the society hosts, whether it is the Isleños Christmas or a *fiesta campestre*.

"This is where the kitchen used to be." She gestures around the room we are in. "And they always, no matter when you came, they always said, 'You gotta eat, you gotta eat.' I'm like that. I always want to feed people. Speaking of that—you want something to drink?"

I smile and wave my hand no. "What makes this house so special?" I wonder aloud.

"This is my mother's family's house. My grandmother on my mother's side, my maternal grandmother, and all the way back, was a Ruiz. My great-grandmother was an Esteves."

The house has been passed down, family member to family member, on the Spanish side of her family since its construction in 1914. Over the years, as it has been there as a shelter for whoever in the family needs it next, it has become more than a house. It's become a symbol of how the Isleños preserve things for the next generation.

"I have things packed in the attic—just like coffeepots and little whatnots, things that were my grandmother's." She pauses. "I'm sentimental. I have a big doll that was my aunt's because my aunt was hit in the head with an axe. She was like a child, and she always had this doll on her bed. I even have my great-grandfather's crucifix."

She puts her hands on her knees and brightens. "I'll give you a little tour of the house," she says. We move away from the sofa and the light of the television, and she leads me into the nearest bedroom.

The bedroom set sports nineteenth-century designs, but Lorraine moves toward the mantel, where images of Christ, the Blessed Family and saints stare back at us.

"The gold crucifix was my great-grandfather's, and you can see that it's old because of the base." She thumbs the bottom of the cross. "And then the Jesus statue was originally out of his altar. The house caught on fire in the late '60s, and the altar was in the house. You can still see the soot on Jesus."

Even the new pieces reflect parts of the past and Isleño emphasis on religion and faith.

"The hanging altar on the wall, I bought it about eight years ago," she tells me. "And this is the exact height I had the altar hanging on the wall. When the water came in the house, the grass line was about a half an inch from touching the altar. It never touched the altar."

We move into an adjacent room, another bedroom, and she flicks on the light. "This bedroom—this bed was original to the house. It was originally one of my great-grandfather's brother's. I was able to save the set."

Over the one hundred years, the bedroom sets, the tables and the chest of drawers have been passed down from family member to family member, whoever needed the house and its contained treasures next. Realizing the cultural treasure that the house has become, Lorraine has worked to restore as many original features as possible.

"This house flooded in 1927. It went through when they broke the levees, they blew the levees up. That was the second time this house flooded. I remember my aunt telling me the water was up to the windowsill," she says.

The house, which has survived several more floods since that one in 1927, had been built to last, and thanks to caretakers like Lorraine, it will certainly go on for another generation.

"And this is Canarian," she says, pointing at framed lace swirls on the wall. "This is Tenerife lace. This is all from the Canary Islands. It's all handmade. It's an art. Just to learn how to do that is an art." She points at the simplest design on the wall. Its loops of lace are still dauntingly impressive. "I mean, look at how they cut out, they take a piece of fabric and how they do it."

We walk toward the back of the house and enter an entirely wooden-paneled, wooden-floored bathroom. A brilliant white bathtub sits in an alcove in the corner.

"This was the original back porch," she says, gesturing to the rich wooden planks surrounding us on all sides. "I was able to save all the boards—take

them down, clean them and sand them and put them back up. All the walls are cypress; this is the original flooring. So it's all original wood on the floors."

"Original from 1914?" I ask.

"Original," she confirms. "This was the back porch."

Over time, as the family expanded and the number of children increased, the porch was enclosed and turned into a bedroom.

"I had a guy come look at it to refinish the floors, and he wanted too much," Lorraine admitted. "So I said, for that price, I could put all new wood down. So I pulled all the wood up with intentions of putting new wood down. When I thought about it, this was my grandfather's bedroom. That was something they always told me. Every night, he always kneeled on his knees and said his prayers. He never missed a night without praying on his knees. So after I started thinking about it, my great-grandfather prayed on that wood. That was his floor he said his prayers on. I cannot throw that away."

"This house is a living history," I say.

"I don't believe in spirits," Lorraine says as we walk back into the living room, "but I know that they know that I have it. This is where the kitchen table was. I can still hear them in here, drinking coffee. You know, every night, they had to have a cup of café au lait. They always had ham sandwiches. They always had their sandwich and their cup of coffee at night. I can still smell the coffee."

"Family ties," I murmur. "Look at you with the house. The Spanish part of your family has passed this house and kept this house in the family for whoever needs it next. You pass it on."

"I think that's what made the culture last," she says. "No matter how bad it was down there, everybody always just tried to help everybody."

On one obvious level, this house is just that—a house, something made of wood and walls, built and rebuilt, added to, expanded and lived in. But in another, more symbolic approach, Lorraine McDaniel's house represents a key part of Isleño identity—the desire to provide for and pass on their ways to family and to that next generation that inevitably comes. All of the parts of culture discussed in this chapter ultimately have survived because of this same mentality that allows Lorraine to have this old house today—and will allow others in her family to one day do the same in the future.

CHAPTER 6
HURRICANE KATRINA

People brave enough, or sometimes foolish enough, to stay in southeast Louisiana live with the yearly possibility of being wiped out. From the beginning of hurricane season on June 1 to its end on November 30, Catholic churches in St. Bernard Parish, including the old Isleño St. Bernard Catholic Church, offer up prayers every Mass to ward away any storms: "Our Father in Heaven through the intercession of Our Lady of Prompt Succor, spare us during this Hurricane season from all harm. Protect us and our homes from all disasters of nature. Our Lady of Prompt Succor, hasten to help us. We ask this through Christ our Lord. Amen."

As they enter the real sphere of danger in mid-August and September, interest grows in "watching the weather" during the nightly news, and whenever the faintest murmur of a tropical depression, a swirl of a cloud or a grimace on the face of Bob Breck or Margaret Orr on the local weather segment appears, the news spreads down the checkout line at the grocery store, through the aisles of drugstores and past the public library until it has reached every soul in the town.

But no one saw Hurricane Katrina coming. Even by late evening on Friday, August 26, only days before the storm's arrival, not many in the area knew about the threat in the Gulf. Archbishop Hannan High School in Meraux enjoyed its first football game of the season, and seniors in the graduating class of 2006 were looking forward to their weekend retreat the next day. According to weather agencies, Katrina was supposed to turn and head toward the Florida Panhandle, leaving Louisiana safely out of harm's way. No one, not even the Isleños who should be able to smell a storm coming by

this point, knew about Katrina. No one realized that these moments—the cheers coming from a high school stadium, the chatter of parents, the drive past homes with lights on and doors in their frames and people inside, eating dinner, playing games, resting on the sofa after another long workweek and just simply living dry—would be the very last ones of their normal world.

By Friday afternoon, it became clear that Katrina was not turning at all. Instead, the storm unexpectedly abandoned its projected path and sped toward Louisiana. By Saturday morning, the parish's grapevine had raised the alarm. Hannan High's senior retreat was canceled, families began loading possessions into the trunks of their cars, local government officials encouraged evacuation and distant hotels began filling up with reservations.

Despite the warnings from weather channels and mandatory evacuations, the suddenness of Katrina's change in course made the danger seem less threatening, less real. Once aware of Katrina's possible change in course, the *Times-Picayune* reported on noon on Saturday, August 27, that "St. Charles schools will be closed Monday and Tuesday and Jefferson Parish schools will close Monday, officials announced. New Orleans public schools will close on Monday if Mayor Ray Nagin orders an evacuation. 'We'll make decisions on the rest of the week based on the storm and the damage,' said spokeswoman Pat Bowers."[1]

By this point, everyone knew the magnitude of Katrina and had seen pictures of its massive span and sheer strength, but no one seemed to realize the destruction the storm would bring. By Sunday, the *Times-Picayune* reported that "at least 130 people" had entered shelters at St. Bernard High School and Chalmette High School.[2] Many others in St. Bernard Parish, not fully believing that Katrina could be such a threat so suddenly, waited by their televisions or in line to buy gallons of water and canned food or by boarded-up windows—and then in contra-flow traffic as they fled.

No one had to wait long.

On the morning of Monday, August 29, 2005, Hurricane Katrina made landfall over southeast Louisiana. Just before the storm arrived, Katrina weakened from a category four to a category three, but the amount of damage surpassed anything the area had ever before experienced. The storm's terrible 120-miles-per-hour winds sliced directly through the old Isleño territory. Levees failed and surrendered to rising tides and powerful twenty-five-foot water surges. Winds downed power lines and trees and dismantled houses. Chunks of bridges crashed into the water. Unchallenged flood surges smashed violently through neighborhoods.

Homes, businesses, schools and lives were destroyed in Hurricane Katrina. St. Bernard struggles to recover even today. *Photo by Janet Perez.*

Desperate men and women axed and clawed their way through their roofs to escape the water barreling into their homes. Others were swept away in the waves and drowned trying to grasp the lifeline of a tree or a roof or the outstretched fingers of a helping hand. After decades of substantial wetlands loss, Katrina's effects were devastating. Once the flood waters receded, only a handful of structures in the parish of seventy thousand residents remained untouched.[3]

In the final words of its after-action report following Hurricane Betsy, the Army Corps of Engineers expressed the hope for a better outcome in the wake of future storms. "It is hoped," officials wrote, "that the above observations will be of some value to other Corps of Engineers districts in preparing for future emergencies resulting from hurricanes, tornadoes,

floods, or other natural disasters." It did not matter whether the current corps workers read the report or whether the suggestions were or even could be implemented because Katrina quickly became the natural and man-made disaster that Betsy's generation of corps, with their good intentions, had hoped to prevent.

When Katrina hit, the world stopped. Right there, in that second—houses breaking, tree limbs shaking, levees buckling and people drowning—everything normal vanished. The drama is justified. Hundreds of thousands were left homeless, more than 1,400 died in Louisiana alone and bloated bodies were washed out to sea. Katrina caused $81 billion in damages, forced hundreds of thousands of refugees to shelters spread across the Gulf South and flooded about 80 percent of the Greater New Orleans Area—and somewhere in those statistics are the Isleños, thrust by wind and wave into a different world. Even after recovery, the Isleños who have returned now face a changed parish with unfamiliar faces and fractured traditions. The new "normal" that replaced the old was nothing like what they had known before.[4]

To be fair, August 29 was never a stellar day in history. In 1756, Frederick the Great of Prussia attacked Saxony and launched the Seven Years' War. Shays' Rebellion was started on that day in 1786. The Second Battle of Bull Run during the American Civil War happened in 1862. The Quebec Bridge collapsed in 1907, killing several dozen workers. The Soviet Union tested its first atomic bomb in 1949, and in 1966 the Beatles performed their final concert for paying fans.

For a day of destruction, sadness and loss, August 29, 2005, lived up to its predecessors for the local Isleños. By Monday afternoon, more than three hundred St. Bernard residents had reached the now damaged shelters. Levees failed in both the upper and lower parish, and the water rushed into St. Bernard.[5] Communication was scarce, and families were desperate to hear from loved ones. The news crews focused almost exclusively on the city proper, the Ninth Ward, and the atrocities in the Superdome, and St. Bernard residents received little news about their own home.

The immediate aftermath of the storm proved to be as dramatic as the flood itself. The world was a war zone. Unlikely heroes canvassed the canals that were once streets, looking for survivors. Looters ransacked homes. Across the country, displaced residents hovered beside televisions fixed on any channel that gave them news of home, whether in hotels or motels or utter strangers' living rooms. By Wednesday, August 31, "about 2,000 people have been rescued in St. Bernard Parish, but there are still people on

rooftops."[6] By Thursday morning, the *Times-Picayune* reported one hundred dead in Chalmette with food supplies and clean water running low.[7] Polly Boudreaux, clerk of the St. Bernard Parish Council, begged for help for the parish and those stranded there. "St. Bernard has been rescuing St. Bernard for days," she said, crying. "Everybody is in need. Everybody has just been wiped out."[8]

For the Isleños in St. Bernard, already weakened by World War II and the second half of the twentieth century, Katrina was a near killing blow. The parish had served as the home of many Isleños for centuries, and the almost total destruction of the area left the Isleños there homeless once again. For various reasons, Katrina was worse than the disasters before. Like in the Flood of 1927, many Isleños blamed the government, especially the Army Corps of Engineers, for the disaster, and distrust for outside authority festered. With their homes ruined (oftentimes missing from the slab altogether), their livelihoods threatened and whole families hesitant to move back once more, people began to relocate to other parts of southeast Louisiana. Many Isleños had simply just had enough.

For those who have returned, the parish is not the same. Traditional Isleño neighborhoods vanished when families refused to return, and new people, many of whom were not St. Bernard residents before Hurricane Katrina, moved in. Post-Katrina St. Bernard was a blur of new faces, new businesses and new routines. The Isleños, however skilled they are at adapting, typically do not like change, so the forced adjustments and transformed world they returned to often did not measure up to the world they once had. This characteristic is possibly one engrained in human nature—to cherish the past and only warily embrace the future—but for the Isleños, it borders on a fault. Nostalgia grounds them but often prevents them from fully moving forward. As a result, hardly a day goes by that someone does not mention "the time before Katrina" or "before the storm." Nothing is ever quite as good as they once had, and the post-Katrina St. Bernard is no exception.

For better or for worse, the fate of the Isleños has become irreversibly linked to the fate of St. Bernard Parish. Canary Island descendants, of course, remain in other areas of Louisiana, especially near Donaldsonville, where many of the Valenzuela Isleños now live. However, the social cohesion that has preserved Isleño culture is an attribute of St. Bernard, isolated and vulnerable. Because of its separation from the rest of the state, St. Bernard

served as an incubator for Isleño culture in a way that the Isleños on Bayou Lafourche never experienced. As a result, the Isleños are subject to the storms of St. Bernard, the political decisions of its council, its rising tide and its sinking ground.

More devastating than the flooded buildings and physical loss was the immeasurable damage done to Isleño culture. Hurricane Katrina badly bruised the recent efforts to preserve the traditions of the Isleños in St. Bernard. Floodwaters destroyed the Los Isleños Museum complex, and countless artifacts from Isleño history were swept away in the tide. Those fishing camps in the nearby waterways were torn apart by winds and waves. Some of them were violently pushed across the canals and into the marsh by the power of the surge. Others were completely grabbed by the waves and lost to the Gulf forever. Bits of life before—a lamp, a plank of wood, an inner tube—washed up onto the shores, but the rest was gone and with it went the way of life that kept those Isleño families together.

Most tragic and distressing has been the dismantling of Isleño communities. This togetherness maintained Isleño tradition for generations until World War II began to draw them away from isolation and into the world. The Isleños managed to hold on for another six decades, but Katrina was the killing blow to this unity. Whole Isleño families moved away from St. Bernard in mass exodus. For those who returned and rebuilt, some of the core tenets of Isleño identity were left shaken. Without nearby family, cousins, aunts and uncles could no longer easily come together. Instead of seeing one another regularly, they now have to schedule visits and get-togethers into increasingly busy, modern lives. New generations no longer grow up together, and the older generations have a more difficult time passing on their ways to their children.

In her work on memory, trauma and the Holocaust, Marianne Hirsch once wrote that "the children of exiled survivors, although they have not themselves lived through the trauma of banishment and the destruction of home, remain always marginal or exiled, always in the diaspora. 'Home' is always elsewhere."[9] A similar statement can be made about those Isleños who moved away from traditional Canary Island areas following the storm. Initially, the children of this next generation will hear the stories of the current one—those who went through the storm and how things used to be—and home will remain that perfect memory of a pre-Katrina St. Bernard. But with every generation away from home, away from this cultural hub, parts of their identity will inevitably fade as they assimilate

into their new environments. Those families who moved away often bought houses near to one another, but after this current generation and without the mechanisms that kept their culture alive, their children will most likely conform and integrate into the fabric of their new neighborhoods.

The sad reality is that the older generation of Isleños, the ones most in tune with their heritage, are often unable to undertake the traumatic and demanding process of starting over, and most young Isleños look beyond the canals of St. Bernard or the inlets of Bayou Lafourche for livelihoods. More Isleños attend college, and few return to jobs of fishing and trapping, the kind of back-breaking occupation that requires callused hands, not advanced degrees. Because of the ailing job market, many are willing to move away from the state to find decent careers in other fields. Modern Isleños lack a necessary young generation that is active in their culture to take the place of the old. As a result, with every death of a matriarch or Isleño grandfather, key aspects of their culture fade into memory. Without the social cohesion that has preserved their culture for generations, parts of their identity will undoubtedly be lost to time.

How this dilution of Isleño unity will play out and affect their future is unknown, but we can predict a plausible if bleak assumption. Some Isleño social leaders in these decades following World War II have certainly made valiant attempts to actively preserve their culture, but setbacks like Katrina not only negate their best efforts but also set the Isleños even further back than before. With the Los Isleños Museum destroyed, countless irreplaceable collections of historic pictures were lost. Valuable re-creations of Isleño dress and stores of research were damaged beyond salvaging. All of their work must be redone, their efforts redoubled, before future progress can be made.

The Isleños are survivors, but they face a Catch-22 that might lead to their own extinction. Their stubbornness to consistently return and rebuild after every disaster is laudable, but after every storm fewer Isleños return, and the solidity and unity that has kept their culture intact now wanes. These disasters eat away at the Isleños slowly, like a cancer. The Isleños have become so firmly rooted in their ways that they are unwilling to change and take measures to consciously protect what is at stake. Instead, they move back and struggle to continue where they left off, each time fewer in number and in cultural strength.

Conversely, even if the Isleños did move away from the wavering coastline and formed new communities in a safer location and higher ground, they still risk losing their identity to the pull of Americanization and modern

convenience. Their location in the marsh, despite its natural hazards, has offered isolation and protection from outside influence and thus preserved Isleño tradition from dilution. Just look at those Isleños who did move beyond St. Bernard and Bayou Lafourche following World War II—within a generation, they were now removed from Isleño unity. Furthermore, Isleño culture has become tied to the environment. From their beginning as farmers to their current existence as fishermen, the water and marsh have become vital elements of Isleño experience. Without the presence of the marsh, Isleño identity will undoubtedly change. Ultimately, if the Isleños stay in coastal Louisiana, they face a slow degradation of their culture, once strong but growing progressively weaker with every generation and every disaster. If they leave, they still risk the dissolution of their customs, because only the coast can truly offer them the isolation and livelihood they need to continue their legacy. Unfortunately, the Isleños have found themselves in a situation where they are damned if they do and very damned if they don't.

Living in the same way as had the generation before has preserved Isleño tradition for centuries, but as the Isleños gradually leave their parishes, their strength in numbers dwindles; by not changing their ways, they risk losing it all. What is to stop a new storm—a new Betsy or a new Katrina, more powerful than ever now because of the eroding marsh—to once again destroy the museum the Isleños have worked so hard to reconstruct? And what will happen after this dedicated current generation is no longer there to rebuild? By only returning and not learning from the past, the Isleños are potentially securing their own demise.

The Isleños continue to band together in smaller groups in places across south Louisiana—Bayou Lafourche, Donaldsonville and Pearl River— but after generations, the fate of the Isleños has become permanently tied to the marsh and to St. Bernard. Thanks in part to the disasters of the twentieth and early twenty-first centuries and a greater willingness to move beyond parish lines, St. Bernard has suffered the loss of property and population, and the state of the Isleños has weakened. In many ways, theirs is a losing battle.

Recovery from the storm has been slow and painful and in many ways is still incomplete. For years after the storm, active National Guard troops remained in the area, patrolling through streets in the Ninth Ward of New Orleans. Not a day goes by that someone doesn't mention the hurricane, and abandoned homes—marred and disfigured by large spray-painted X's

and smothered by mold on interior walls—have become blighted property, eyesores and harsh reminders of what once was.

Beginning as early as September, residents started to trickle back to gut their houses. Downed trees and power lines blocked access to many parts of subdivisions. In other areas, whole houses that had been uprooted and swept off their foundations now stood in the middle of streets. Red Cross vans maneuvered through nearly deserted neighborhoods and brought hot meals to men and women working on their homes. During the day, there was nothing except the sweltering summer heat and sweat and the absence of any electricity to power an air conditioner. At night, there was nothing but stars and stillness. Flies easily found their way past broken-down doors, where they settled on the wet mud stuck on the carpet and buzzed obnoxiously against the dirty glass of windows. Snakes lurked in cracked pools and kitchen cabinets, and alligators waited in bathrooms. Faded ink drained color from photographs and erased any potential trace of the time before. The world was a mess.

Those who moved back had to deal with the effects of two catastrophes—the one caused by nature and the other caused by the looters. A number of homes with two stories had only flooded on the bottom level, leaving possessions on the second floor otherwise safe and dry, but many of these homes were broken into and trashed in the immediate aftermath of the storm. Valuables were stolen, and walls were vandalized with graffiti. The remnants of crime clearly lingered in the parish and mixed with the rest of the destruction there.

Besides the universally hated shade of "FEMA blue" (the color of the FEMA-issued tarp), one of the worst parts of Katrina recovery was the unbearable smell that engulfed everyone and everything in the parish. It was the stench of several different types of mold on the wall, rot and decay, stale mud on the floors, rust and death, sweat and tears—and it was everywhere. It penetrated everything, latched onto clothes, skin and brain so closely that it was all anyone could ever smell as they made the long drive back after another exhausting day of gutting and smashing and scavenging through a million broken, dead things to the wherever they were staying—that somewhere that wasn't home.

It was the hell that every Isleño generation has to live through, but because of the magnitude of the destruction and the difficulties in moving home, many families—some whose ancestors had been the original Canary Island immigrants—made the decision not to return. Perhaps this generation's willingness to move stems from the dilution of Isleño culture

since World War II, and perhaps not. Cousins, aunts, uncles, brothers and sisters once all lined the streets of neighborhoods and worked and lived as a single unit, but this is now rare. Once they all spoke Spanish and worked exclusively in the parish, but this is still rarer. Too many have moved away, and too much has changed.

Researcher Sara Ann Harris understands the grim reality that Katrina created for the remaining Isleños in southeast Louisiana. She has studied and interviewed members of the Isleño community for years, and she has watched their culture adapt and change in the last generation, especially with Hurricane Katrina.

"I would call it the last blow," she says honestly, if bleakly. We both swat at the swarm of gnats around us at the Bayou Sauvage Wildlife Refuge. The marsh grass waves in the breeze, and a duck paddles past the wharf below us.

"The environment was everything when you live on the Mississippi River," Harris says. Her hands stretch out to indicate the open expanse of marsh around us. "The Mississippi begins to break up into a number of tributaries somewhere just south of New Orleans and runs down to the Gulf of Mexico. It's basically all water, running down to the Gulf. The only landform is that that's built up next to the bayous and river. There are small spits of land, small bits of high ground. So that's where the people settled when they moved that far south because it was the only place where they could build a palmetto hut."

"The water was everything," I reply. Whether as fishermen or farmers, the water around them had a commanding authority in how they lived.

Harris nods.

The Mississippi River had everything to do with where people settled and everything to do with how they made their living, either fishing or hunting. The forces of nature dictated everything—the seasons, the tides, the rains, the temperatures, the high waters, the hurricanes. They described their lives as either feast or famine. Either the weather and the forces of nature were permitting to catch and enjoy and share and celebrate, or they were breaking you down and taking your family members in storms and destroying your boats. It was quite a contrast. The force of nature was both a nurturer and a harsh mother, if you will.

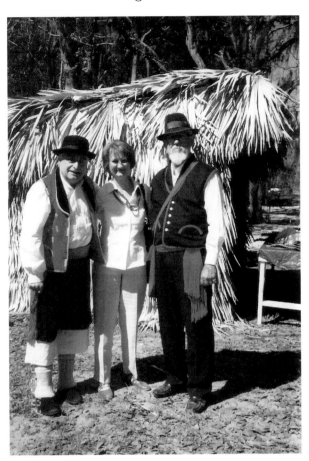

Two Isleño men in traditional dress stand in front of a reconstructed palmetto hut. Early immigrants built huts such as these for shelter. *Courtesy of Dorothy Benge.*

What is left unstated is the obvious—the water still has that commanding voice over the Isleños, and floods like Katrina are the result of living in such a place.

"How did Katrina affect the Isleños?" I ask.

"I would say that it's the last blow to that elderly community," Harris replies grimly. "Many, many of them died not just in the storm but after the storm. Funerals actually became great reunions. People would come from every place they had evacuated to. You could see that the spirit of that community was still there. They very much wanted to be together; they very much understood the importance of who they were. But they've been thrown asunder."

"Isn't there anything the next generation can do?" I ask. I swat at another gnat, but ten more take its place.

She shrugs. "In terms of a traditional community, the family life has gradually been changing," she explains. "There's another generation there who, before Katrina, was fishing and shrimping, but the elders described them as a very different ethic."

"How so?"

"You know," she says, "as far as the identification with the land or taking a great deal of pride in your work or learning your skills and your values from generation ahead of you. The generation who was there before Katrina were no longer living that way. Of course, each generation is going to reshape itself and become someone else."

"But it's getting to be too different now," I say. "Too much has changed in the recent generations." The gnats close in around us as we look out at the marsh. Since World War II, the Isleños have experienced a dilution of culture with every generation. Bits of those traditions have been lost. That culture is what the Isleños have sacrificed to provide a college education for children, to achieve better jobs outside the water and to secure safety away from a flooded land. Maybe the benefits of that decision outweigh the loss of their customs. Only time can tell.

The sun is already rising in Shell Beach, and the August heat is sweltering under the blanket of muggy, motionless air. Men and women gather closer together under the assembled tent and use the folded programs as fans powered by fast-pulsing wrists. There is no wind. Only a few puffy white clouds float aimlessly above. Nothing can ward away the heat.

It is the morning of August 29, 2009, exactly four years since the landfall of Hurricane Katrina, almost down to the minute. Parish council members and the parish president mingle with representatives from state senators and FEMA agents. Chalmette High School's student choir assembles nearby as the people talk amongst themselves about the past, the present and the now universal topic of the storm. Beside the tent stands St. Bernard's Hurricane Katrina Memorial, a large monument on the water's edge that bears the names of all of the storm's victims in the parish. Several Isleños names such as Morales and Lopez are etched into the black plaque of the monument.

The day could not be any more different than the August 29 four years ago. Without any wind to help it unfurl, the American flag by the podium under the tent hangs limp on its stand. Mullets jump in and out of the calm water. A few seagulls take flight from the pylons just off the shore nearby,

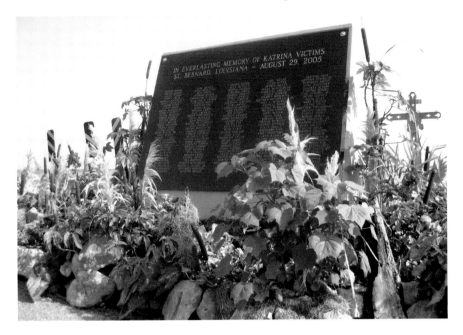

St. Bernard Parish erected the Hurricane Katrina Memorial to honor the lives lost in the storm. Many Isleño names are on the list.

and a flatboat full of fishermen causes a gentle wake that sloshes against the rocks. They give a silent wave as they pass. The sun is still rising.

Father John Arnone, the new priest at the St. Bernard Catholic Church where the Isleños have gathered since the 1700s, steps to the podium. "And so we pray," he says. Heads bow. The choir slips away to the side of the tent as he begins to speak.

"God of all creation, we gather this morning, taking time out of our busy schedules to pause, to be still," he says, "to be mindful of your presence as we reflect on the events of four years ago this day."

A few of the cameramen from the local news crews lurk in the back, and their cameras slowly pan back and forth, back and forth at the crowd of men and women. Some are weeping, some are staring and some are praying.

"As the wind, the water and the sky swept over our beloved city, state and parish, this sacred ground we stand upon, we reflect on those who lived, worked and visited," he goes on. "Those who have helped us grow into the people we are today."

The Hurricane Katrina monument stands like a monolith overlooking the water. Flowers rest at its base, and the sunlight makes the engraved names on

its black surface seem to glow. A memorial cross stands like a pylon itself just off the bank, and Christ's mournful face stares back at the gathered crowd.

"With heavy hearts still and emotions stirring on this anniversary, we remember those who died and the material losses that occurred, mindful that we are people of hope," he says.

What kind of prayers did Friars Mariano de Brunete and Agustín Lamar, the first priests of St. Bernard Catholic Church, give after their disasters two centuries ago? What can you say after destruction? Did the Isleños then also think of hope?

"Looking to the future for new and exciting opportunities, building today and tomorrow on the many yesterdays that have gone by, we give you thanks for the countless acts of charity that we have witnessed, the outward pouring of love and concern, volunteers and agencies that have come to lend a hand, helping us with rebuilding efforts." The people shift a little on their feet.

"Continue to give us the graces and blessings to move forward, to become stronger and better, to be brother and sister and mother and father, to one another as we journey together. Bless our efforts, comfort our hearts and enkindle your flame of faith in our lives as we are mindful of your presence and seek your guidance day by day."

Father John looks up. "And through intercession of Our Lady of Prompt Succor, may we be spared loss of all life and property during this hurricane season. Amen."

"Amen," they reply as parish president Craig Taffaro and the members of the parish council step forward and read the names of the St. Bernard residents who lost their lives during the storm.

"Bertha Acosta."

A pause.

"Douglas Arceneaux."

The mullets jump again and disturb the water with a splash. Ripples spread.

"Walter Cosse."

Four years ago, the storm was rolling in at this moment with wind and fury. Now the air is dead, the water is calm and behind them are buildings only partially rebuilt.

"Charles Gagliano…Shirley Gagliano."

Four years ago, survivors had to wait on rooftops under the same August heat, sweating, dehydrated. They waited for rescue. They hunted for food. They rode in boats and searched for other survivors like themselves. They

sat cramped in shelters, they waited on interstates, they shouted for help and they beat the rising tide. The parish council members read more names. The survivors who once waited on their roofs are the lucky ones.

"Arthur Galatas."

Members of these families gather on the water's edge and together touch the memorial wreath that is waiting for them there. Its blue bow quivers as they lift it from its stand.

"Tufanio Gallodoro."

They kneel down beside the rocks.

"Todd J. Lopez."

Gently they set the wreath on the water and push it away from the bank. It bobs for a second and then steadies itself and floats away.

"Lauretta Morales."

Together they back away from the rocks, from the wreath, from the water, and everyone stares at the flick of green and blue and yellow rolling with the gentle waves.

Every year, residents of St. Bernard gather near Shell Beach for a memorial ceremony to remember their losses in Hurricane Katrina.

"Rosemary Pino."

The paper fans have stopped beating. People have given in to the heat. Men and women are crying, and a few now clutch tissues with white-knuckled fingers as the current continues to take the wreath away.

"Antonia Sanflilippo."

With more than 150 names on the memorial and in the air, this annual service is a uniting emotional renewal for many St. Bernard families, Isleños or not. Remembrance brings them together on this morning. Almost everyone knows someone who died in the storm, but even for those who do not, the memorial service serves as a way to remember everything else that was lost and everything that was gained.

"Dorothy Taguino."

The wreath is farther away now, a dot of color in the canal. Everyone reflects as the tide takes the flowers away.

"Gloria Young."

Behind them, the sun continues to rise.

It has been five years since the storm now. On the surface, down the main roads, in the flashing signs of stores that have reopened, everything looks like life has returned to pre-Katrina normalcy, but past these main roads, within the subdivisions, houses still stand, derelict and abandoned, and grass grows unchecked into giant green stalks. It has been five years. Boards cover windows, and after five long years, spray-painted X's still stain the front of houses left behind. It has been five years, and progress remains constantly marred by physical reminders of the storm.

To put this tragedy behind them, residents in St. Bernard gathered together on August 28, 2010, one day before the official anniversary, and hosted a funeral—for Hurricane Katrina.

Hector and Karen Perez sit at their kitchen table and fold their hands as I tap the red button on my tape recorder. Although not an Isleño himself, Hector has become involved in the Spanish community in St. Bernard.

"I moved here when I was six years old. We blended right in with people," Hector tells me.

It does not hurt to have a last name like Perez.

"Everybody was always asking me if I was related to Leander and if Judge Perez was named after grandfather, but we're not related to anybody Perez because my grandfather was from Guatemala. Somewhere down the line, I'm sure we're already related," he jokes.

"So how were you affected by Hurricane Katrina?" I ask.

Karen across from me sits up in her chair and leans against the table. "I left with the kids on Saturday," she says. "We loaded up and went to Texas. It was Monday that we learned that everything had been flooded."

"Luckily I left at the last minute," Hector recalls.

"When did you leave?" I ask.

"Sunday at 4:00 p.m. I was staying, figured I'd ride it out. I even cut the grass that day," he says. "I figured I was gonna come back. The grass was high, and I said, 'Man, I better cut it now because it was gonna rain, and then in three days, four days when we come back, I'm really gonna be in a mess.' The winds were really picking up; the forecast was going to be bad. I don't know what came over me. I said it's time to go."

The recovery process has not been easy for anyone, but both Karen and Hector had the same idea to come back and rebuild their home in St. Bernard. It took years to finish their home, juggling work with repairs. They found schools for their daughter and son and a decent apartment to live in as they rebuilt.

"But it was good that we had the same idea to come back," Karen tells me. "So many husbands and wives were torn—come back, not come back. One of them wanted to, one of them didn't. We didn't have that problem. It worked out."

"What about the Katrina funeral? What was the event like? What was it?" I ask.

"They had a casket in front of church," Karen describes, "and they had slips of paper that you could write, whether it was memories or something that you wanted to bury. You could write it down, and you went to put it in the casket. Before the Mass started—or the service started—they closed it. It just symbolized it's gone, that's it, it's over."

"I thought it was very nice," she goes on. "The preachers that talked were good, saying, 'You know this bad thing happened, and we're gonna move on. It's made a lot of us stronger; it made us realize that we could do things that we never thought we could do before. We didn't want to go through it, but we did it.' I guess they did it for a healing-type thing. Floyd Herty was saying, you know, that he's tired that every time he talks to somebody, it was always, 'Before Katrina…Before Katrina.' So I think his theory was, if we had the funeral, we can say, 'It happened. Now let's move on.'"

Karen starts to laugh. "When they closed the top of the coffin, and everybody started clapping, the archbishop was like, 'I've been to many

funerals before, even for people that weren't very well liked, but I've never heard clapping when the casket was closed!'"

"I guess it's like a book," Hector adds. "You have chapters in it. And Katrina happened—a chapter. Sooner or later, you're going to finish that chapter and go to something else. Let's bury Katrina—it happened, we know it happened. We're doing things to get better. Yeah, we had problems, but let's close that chapter and open up a new chapter. It was very symbolic to me, that we went to that funeral, and we took care of Katrina."

"Did you notice a difference in your outlook after the funeral? Have you made a conscious effort to change?" I ask.

Hector smiles. "I feel since Katrina, though, I've been kinda taking life a little bit easier, going slower. Now I let people in on the interstate when they come on the on ramp. Whereas before Katrina, I would hurry up and go past them. Now I'm letting them in, after Katrina."

"That's so nice of you!" I tease.

"It's really nice of me to let them in! I know!" he says.

We're all laughing, but as we die down, he adds more seriously, "It's amazing how you look at life differently after Katrina."

Karen elaborates:

> *The people that we have met, the volunteers that have come down and helped. They don't think that there's anything that they're doing that's special. When we were in Baton Rouge, a lady came up to us. The lady wanted to know where something was in the church. I didn't know because I was new, and I told her that. She said—she wanted to know if we were here for Katrina. And she handed me a check for twenty-five dollars, and it was like, "Here, you need to replace something." And we kept meeting people like that! It was out of the goodness of their heart.*

Hector remembers a different time they met a stranger who offered them help. "I remember we were staying in the hotel in Houston, and we were in the lobby," he says.

> *It was about a week after the storm. They had a phone call at the desk, and the lady at the desk asked, "Is anyone here from Katrina area?" I said, "Yeah." I took the phone call, and it was a lady, and she wanted to know—they were calling the different hotels—and they wanted to know if anybody at the hotel needed anything. They could provide whatever they*

could to help them out. I said, "Ma'am, thank you—I'm okay, we're okay here." I handed the phone to clerk again. I said, "I didn't know who else to give it to." It was unbelievable that somebody would call at random hotels to see if anyone needed anything. I started to cry—I cried—I said, "Man, look at this, this is amazing."

"It's amazing the people that you don't know out there in the world that might help you," Hector sums up. "It's a truly amazing thing. There's good people out there—there's not just bad people—there's good people, too. More good people."

As givers themselves, they stress how hard it was to be on the receiving end of that charity. Every month they provide meals for the volunteers who come down to St. Bernard and dedicate their time to rebuilding the parish. They had a hard time accepting the generosity of others after the storm, but they have embodied the whole axiom of passing kindness forward.

Hector sighs. "I still talk about it," he admits, "but now I say, 'Well, it's something that happened, it's over with.' It doesn't bother—I guess I shouldn't say it doesn't bother me, but it's over with."

Elements of the Katrina chapter still carry on into their new stories. People, Isleños or not, still start sentences every day with "Before Katrina…" or "After Katrina…"; it's a mile marker that will never fade from this current generation. However, Karen and Hector Perez prove that gradual and emotional efforts are being made, step by step, day by day, to close this chapter once and for all.

CHAPTER 7
DEEP WATER AND A NEW HORIZON

The five long years following Hurricane Katrina were years spent on recovery. Isleño residents of St. Bernard and Plaquemines Parishes worked to rebuild and recover what they had lost in the storm, and after a while, something like normalcy returned to their everyday routines. Even though the camps were destroyed, many were able to return to work on the water. Others helped clean out the debris-filled canals so that people could return to fish for fun on weekends. Life in these areas, although forever different than before, began to reassume old habits and a sense of the ordinary.

But just as the dust began to settle after Hurricane Katrina, a different kind of disaster disturbed the Gulf and its shores and once again interrupted coastal lives. On the night of April 20, 2010, less than five years after the storm, British Petroleum's *Deepwater Horizon* oil rig in the Gulf of Mexico exploded, killing eleven workers, and began spewing millions of gallons of oil. The burning rig, only fifty miles southeast of Venice, Louisiana, soon crumbled into the water.

On April 22, officials were still uncertain but optimistic of the potential extent of destruction caused by the oil spill. The *Times-Picayune* reported that "the rig was spilling 13,000 gallons an hour yesterday, but virtually all of it was burning off. Now that the rig has sunk and the fire is out, crews are trying to contain the oil, which may still be spilling into the Gulf."[1] The following day, another article cited "encouraging reports that no oil was leaking from an undersea well the rig had drilled, easing concerns that a catastrophic oil spill might result from the Tuesday night explosion."[2] Reports like these,

which were all the residents along the Gulf Coast knew, offered a sense of ease and reassurance that they did not yet realize was false. No one knew how wrong the reports really were or could fathom the depths of damage that would soon wash ashore. With Katrina so soon behind them, no one on the Gulf Coast could fully believe that they already faced another disaster.

Only days after the explosion, however, people waiting anxiously on the shore all along the Gulf Coast began to realize the severity of the new situation as the media revealed more information about the oil well disaster. The *Times-Picayune* now reported that forty-two thousand gallons were leaking from the rig per day from five thousand feet below the surface of the water, but those estimates quickly escalated.[3] Wildlife—every creature from fish and seagulls to dolphins, turtles and pelicans—in the Gulf began to die. Images of oil-slicked pelicans made their way onto national television, and the worst parts often went unreported until after the event. Animals trapped in the inner oil sheen could not be rescued, and when the black mass started creeping north, the oil was set ablaze. In the process, hundreds of sea animals were burned alive. The oil spill garnered global attention, and once again the Gulf Coast received the aid and generosity of volunteers and donations, but no proposed solution solved the problem of the gushing well.

And all the while, the oil spill grew larger. By May, it was the size of Puerto Rico and soon became the largest accidental oil spill in American history. Despite extensive placing of boom, the oil reached Louisiana by the end of the month. Isleño fishermen who had returned to their work after Katrina struggled to face yet another calamity. Dependent on the money they made from shrimping and trawling, many accepted compensation from BP, which sent aid as staff combated rough seas and tried plan after plan after plan to stop the oil. St. Bernard Parish and BP commissioned local fishermen to replace their crab traps and shrimp nets with boom and to skim the surface for tar in the parish waters.[4] But not everyone could be hired. Because of internal and external factors, including not enough boom and too many volunteers, unemployed Isleño fishermen questioned the parish government's methods in solving the crisis and accused officials of rigging the supposedly chance-based system of selection. Fishermen were chosen for commission by lottery every morning, but some local workers accused those in charge of favoring out-of-town fishermen or friends and family members to do the jobs BP offered. Questions arose over improper allocation of BP-provided funds.[5] As in the many crises in the past, Isleños' distrust for government continued into this latest event.

The Gulf Coast, along with BP, had no shortage of potential strategies for stopping the oil and cleaning up the mess—just a shortage of panacean solutions. BP was futilely trying, amid a media disaster, to stop the leak. The oil giant's first idea was to simply fill the gap with mud and debris. When that failed, other equally unsuccessful strategies were implemented in the coming weeks. BP lowered a large metal container on top of the leak, keeping the oil in it, but because of the depth of the leak, this and other similar methods were failing. Later, concrete was pumped into the Gulf's wound in hopes that it would solidify in the broken pipe and seal it. Beneath the water, in an attempt to stop the oil after it had escaped, BP pumped thousands of gallons of chemical dispersant into underwater plumbs of oil, which only served to make matters worse. Now the waters were filled with oil and chemicals, all washing on the shores of the Gulf Coast. Even professional actors got involved with the cleanup plans. Kevin Costner designed a tool to gather and clean up the oil from the surface. Animal hair stuffed into stockings was thrown into the water to absorb the oil. A final and successful solution to the spill would include a relief well and a secondary pipe placed on top of the original, damaged one, but this plan that would eventually solve the problem would not be finished until months after the initial explosion.

The threat caused by the oil spill prompted angry, disgruntled Isleño fishermen to speak out during parish council meetings on the potential loss of culture. As others shouted about the possible corruption in the lottery or the loss of the season, one local fisherman worried that the oil spill would prevent him from passing on his way of life and his knowledge to his son. Without a stable seafood industry, many Isleños on the coast would have to look for work elsewhere to support their families, another damning blow to the cohesion of Isleño identity.

Meanwhile, oil continued to slosh onto the marsh banks and killed the already-eroding prairie grass. Marsh quickly began to wither, and with it went the coastal towns' best defense against hurricanes. The buffer zone of marsh provided extra land that once sapped hurricanes' strength, but because of the MRGO and now this oil spill, the marsh—and all of coastal Louisiana—is in danger. Thanks to these damages, when the next hurricane approaches, as one invariably will, there will be less marsh to protect the cities when it makes landfall, making the Isleños an extremely vulnerable target.

In mid-June, the Louisiana Department of Wildlife and Fisheries reopened an area of water previously closed to fishing because of the oil spill.[6] This

section and others like it might have been safe to fish, but it was not nearly large enough for everyone who was out of work to return, and consumers were still hesitant to purchase Louisiana and Mississippi seafood. The ripples of the oil-slicked water were yet and have yet to be felt.

Most of the long-term effects of the oil spill have yet to be seen. The fishing industry is beginning to recover, but it will once again take years to fully rebound from the oil spill's setbacks. Many people still do not know or understand that Gulf fish and seafood is safe to eat. The oil forced the shutdown of fishing waters, diminishing the stock of seafood available and darkening the area's reputation for famous cuisine. Amid the turmoil, a local church held its annual Oyster Festival while combating the fear that there would not be enough oysters for its namesake event.

Even if the long-term effects of the spill are still unknown, people can assume that there was more lasting damage done to the coast and the Gulf than meets the eye. On November 6, 2010, nearly seven months after the explosion, scientists discovered dead coral on the floor of the Gulf near where the oil rig once stood. The hard coral, the *Los Angeles Times* reported, had turned brown and was now producing mucus, and the soft coral now sported "large, bare areas." The newspaper quoted Penn State University biology professor Charles Fisher, who was leading the expedition, as saying, "Within minutes of our arrival…it was evident to the biologists on board that this site was unlike any others that we have seen over the course of hundreds of hours of studying the deep corals in the Gulf of Mexico over the last decade."[7] Another article featured Fisher stating, "The compelling evidence that we collected constitutes a smoking gun. The circumstantial evidence is extremely strong and compelling because we have never seen anything like this—and we have seen a lot."[8] After 170 million gallons of oil poured into the water, unforeseen damage is inevitable, but how the spill will affect the Isleño way of life is only something that the test of generations will be able to unmask.

In July, BP capped the well and finally declared the oil spill closed on September 19, 2010. Everyone breathed a long-held sigh of relief, but the damage to Gulf life and to the marsh was done. Like Katrina, Betsy, the Trappers' War, the Flood of 1927 and all of the unnamed hurricanes before and other disasters the Isleños have endured, the oil spill in 2010 removed Isleño agency. Once again they were subject to natural and political forces outside their control. And yet, whether a good decision or not, the Isleños have remained and have gone back to fishing and trawling to make a living.

If it accomplished anything at all, the oil spill, like Katrina, reminded Isleño fishermen how vulnerable a life dependent on the marsh is and proved that very little for the St. Bernard Isleños is truly safe.

The last one hundred years have greatly weakened Isleño identity, but cultural leaders realized what was being lost and began to actively preserve their customs and heritage. In an attempt to combat the effects of time and natural disasters, the Isleños created organizations to protect their language, art, dress, song and community. These groups, including the Los Isleños Heritage and Cultural Society in St. Bernard and the Canary Islands Heritage Society of Louisiana in Baton Rouge, offer classes to make intricate Tenerife lace, help members discover their Spanish ancestors and host lectures from researchers, professors and even guest speakers from the Canary Islands. In the wake of World War II and Hurricane Katrina, they work to keep these vital aspects of Isleño identity alive and intact for future generations.

In Baton Rouge, the Canary Islanders Heritage Society meets to host a guest lecturer on the Canary Islands. The organization formed in 1996 after meeting with some leaders from St. Bernard, and from there the group began to establish itself, form connections in the Canary Islands and explore members' heritage more thoroughly through guest lecturers. The organization's forte lies in genealogy. Most of the members descend from the immigrants who settled in Valenzuela and Galveztown, only twenty-five miles south of Baton Rouge.

After one of its meetings at the Louisiana State Archives building, the society's members Taylor Fernandez and Alisa Janney and current president Rose Marie Powell meet for an interview.

"So did you know that you were Isleños growing up?" I ask. "Did you have relatives that might have spoken Spanish?"

"I didn't hear a lot about the Spanish," Powell admits. "Because the majority of my ancestors were French. My grandfather, who is Spanish, had a Spanish daddy and a French mother. And he would tell me a little about his history, his heritage. But I didn't grow up with a lot of Spanish. I grew up more with French."

Her story is a common one. Thanks to the gradual mixing of Acadian and Spanish bloodlines, the longer dominion of French power in Louisiana and the popularity of the French legacy, no one really wonders about the Spanish period, which only lasted a few decades. Over time, the Spanish

became increasingly affiliated with the French as new divisions were drawn between Europeans and Americans. The spelling and pronunciation of names changed to reflect Italian or French sounds. Now, centuries later, too many people fail to realize their heritage.

"Probably most of us grew up with mostly the French," Powell concludes, "and in later years discovered that they have a Spanish heritage and wanted to learn more about that."

Alisa nods her head. "My family married into Acadians also in Donaldsonville, and it's easy to find that information. You have to dig a little more deeply to find information about Spanish heritage."

"I think my grandfather was more assimilated into the French than the Spanish, even though he has a Spanish name," Powell says. "His name is Spanish, and I guess growing up on Bayou Lafourche and Donaldsonville, I think, you know, I think the Spanish just kind of assimilated into the French."

"They were very much the minority," Alisa adds.

"And a lot of the Spanish names that we have found out later," Powell goes on, "people really think are French and they were not French. They were actually Spanish."

"No question, Spanish was suppressed," Taylor says. "The Spanish isolated themselves. On my French side, they spoke French. We'd go over to my grandmother and grandfather's house, it was all French. I only heard one time—my grandma and my grandpa, they got into a little argument, and they were talking Spanish. One time in my life. And the reason I remember is that I didn't understand what they were saying. I went to mother, and she told me what they were fussing at. I didn't understand. They were speaking Spanish. That's the only Spanish I've ever heard."

"So how is the Canary Islanders Heritage Association working to break that isolation and educate people about their Spanish roots? How are you preserving your culture?" I ask.

"When we had our anniversary celebration in October," Alisa remembers. "We had it at the same time that we had been asked to create a display at the Jones Creek Library. So for thirty days, there was a Canary Islands exhibit. On the second Saturday of the month, we did our anniversary celebration, and on that day we encouraged people to bring traditional Canary Island food and to wear their Canary Island dress. That's probably the most important thing that we do is try to incorporate those traditions into every opportunity that we have. Our speakers are always talking to us about things that are pertinent to the society, to our history, perpetuating our culture."

"And our genealogy," Powell interjects.

"I think setting up the website was important," Taylor adds. "We are in modern times, and that helped us."

"And it gets us national as well as international exposure," Alisa agrees.

Their efforts have worked. Like the Isleños society in St. Bernard, the Canary Islanders Association has a sister city in the Canary Islands. No one needs to prove their Canarian descent to become a member. Instead, the organization links Isleños with those interested in the culture, whether in the Baton Rouge area or by e-mail across the state. They also hold field trips to different locations of historical interest in the area, celebrate a Day of the Cross with Spanish themes, offer presentations, host lectures and plan trips to the Canary Islands, the last of which was in 2008.

"We had all these experiences that we wouldn't have had," Powell says. "You can never replace, never redo the experience that we had when we went over to them."

"We went to a festival and actually participated in the festival," Taylor remembers. "And I saw some similarities between the festival and Mardi Gras, except that was more oriented to family!"

"They weren't saying, 'Throw me something mister,'" Powell quips.

We laugh for a second before Alisa says soberly, "One of the points that I wanted to make that we saw when we went to the Canary Islands—our faces, our shapes, our forms. It was amazing to me just to get off the plane and to just feel like you were home. Because Taylor and I just look so Isleño, don't we?" she says as she laughs and pats Taylor's arm, displaying her pale skin.

"I'm not trying to!" Taylor laughs.

Alisa smiles. "It was really—I didn't expect that. It was like being home."

One of St. Bernard's cultural organizations, the Canary Islands Descendants Association, began in the 1990s and became incredibly active in spreading culture. Before Hurricane Katrina, its members participated in demonstrations of Isleño culture at Jean Lafitte National Park. They had their own dance troupe, and they created a yearlong exhibit on their history for the Louisiana State Museum.

The association had the right idea. The members reached out and involved the students in St. Bernard Parish schools by inviting them to special events called Canary Island Days in which they celebrated their heritage. At the parish's civic center, the Canary Islands Descendants Association

members displayed their woodcarvings and Isleño memorabilia. Irvan Perez sang his *décimas*. The students participated in crafts, and the organization even supplied grants to fund the cost of transportation by the school buses. This way, the young generation became familiar with the Isleños and their contributions to their parish's long history.

Even now the organization meets regularly, but members are still struggling to rebuild in the wake of Hurricane Katrina. In the storm, their museum at the Lopez House suffered six feet of water. The organization lost nearly all of its records, the documents on the group's history, their music and their genealogical work. All they could salvage from the wreck were some bits of glassware. Even in December 2010, the Lopez House is still under construction, and they depend on the time and skill of volunteers to restore the museum to what it once was.

The group's laboring effort echoes the larger problem for all of the Isleños. An active but aging leadership, composed of men and women proud and knowledgeable of their heritage, works to rebuild and restore, but a vastly disinterested next generation is unwilling to learn their ways, their language, their songs, their stories and their secrets. Without the support and active participation of youth, the survival of the Isleños in the modern world is hopeless.

In St. Bernard, Dorothy Benge, the president of the Los Isleños Society, and parish historian Bill Hyland have worked tirelessly with the St. Bernard Parish government and FEMA to rebuild the Los Isleños Museum after the storm. They gathered new artifacts including paintings and typical Canary Island clothes to put on display, and they re-created period homes of the Isleños that guests can tour. Before the hurricane, the museum complex contained palmetto huts in the style of early Canary Island settlers. Those have not yet been rebuilt, but with time and the dedication of the society's officer corps, the museum will one day be fully functional again.

In addition to its monthly meetings, the Los Isleños Society hosts the annual Los Isleños Fiesta, which brings together members of both groups for Canary Island descendants for a weekend celebrating their common Spanish heritage. The festival returned for its thirty-third incarnation at the site of the damaged museum complex in March 2009. Isleño vendors showcased everything from boat models to caldo dishes and sangria, and members gave presentations on local history. Troupes of dancers and singers from the Canary Islands journey to southeast Louisiana to visit their distant

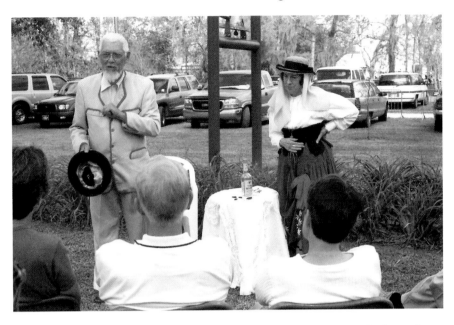

Burt Esteves and Dorothy Benge present a demonstration on the history and culture of Isleños to spread knowledge and understanding of their heritage. *Courtesy of Dorothy Benge.*

cousins in the New World, enjoy the fiesta and share in common traditions. They instruct people at the festival on how to step to traditional Isleño dances and play Spanish games, and they give frequent demonstrations of Isleño *décimas*.

Interestingly, the post-Katrina festivals have drawn support from the new Latino presence in the region. After the hurricane, many Latin Americans moved to St. Bernard and the Greater New Orleans area for work in the suddenly booming construction industry. After years, families began to settle in these towns and enter the social tapestry. Although they are not Isleños, these men and women came to the festival to enjoy common ground, and as Latino families walked around the museum complex, it was a reminder of lost parts of the Isleños' past to hear the Spanish language once again giddily spoken, just like the olden days.

By the next fiesta in March 2010, reconstruction of the Los Isleños Museum was complete, and researchers, artists and craftsmen from both organizations displayed their work in the newly renovated buildings.

Every March in St. Bernard, the parish also hosts its Irish, Italian, Isleños Parade, which celebrates the greatest contributions to the residents'

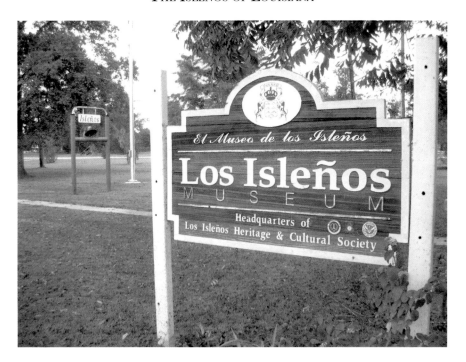

The recently rebuilt Los Isleños Museum in St. Bernard houses artifacts integral to the Spanish history of the area, from traditional clothing to genealogical records.

heritage. Hundreds of St. Bernard citizens gather along the neutral ground and sides of Judge Perez Drive, one of the town's main roads, to watch local company-sponsored floats roll by and catch not only traditional Mardi Gras beads but also cabbages, potatoes, garlic, lemons, sugar from the local Domino's refinery and wooden coins that can be redeemed for pickle meat. School marching bands and dance teams walk by, and members of the Marching Club hand out green, red and white flowers in exchange for nothing but a kiss. The annual parade, which made its much-welcomed return after Katrina in 2007, does more than celebrate the parish's dominant European heritages. True, the parade does not re-create authentic Isleño history, but it does remind the parish of its Spanish past and maintains a sense of community among the parish residents, even if for a single afternoon. Spanish, Italian, Irish or not, this closeness among families and neighbors is what has kept the Isleño tradition alive throughout the centuries, and that cohesion is now more important than ever before.

These internal organizations are not the only help the Isleños have received in preserving their stories and traditions. Dr. Laura Westbrook headed the Louisiana Folklife Program, a part of the Louisiana Division of the Arts, whose mission is to protect the state's unique cultures. When I met with her back in 2009, she described the program's recent achievements.

"It was established to help traditional communities to preserve their living traditions," she said. "We work with artists, craftspeople, people who maintain traditional customs and who have knowledge that's important to the community, whether it's stories or history. We may work with a community to develop a museum exhibit or a festival or a series of concert events or radio programs or whatever the community is interested in doing. Even more so, we work with communities to train members to document their own customs or to help to develop ways to pass traditions on to future generations."

Dr. Westbrook's goals hit the cultural preservation problem dead on. Too many of these smaller, more isolated identities maintain their heritage and folklore through oral tradition and do not always incorporate the methods Westbrook described. By teaching these organizations how to properly document and share their cultures with others, even within their own communities, she made traditions accessible to the next generation. No, nothing will ever be able to replace the passing down of a lifestyle and the growing up surrounded by certain stories and values, but through the interviews she has collected and the museum exhibits she has helped create, others now have experienced parts of these unique cultures, even if it is their own.

"I discovered that if we talk to people about the way that we live—the Friday night fish fry on the water or the way we make our living—the connection between culture and environment becomes very clear, very fast. Isleños have always understood this. They know that their hearts are on the water's edge," Westbrook told me.

No matter what community she is dealing with, Dr. Westbrook just gets it.

However, Dr. Westbrook's work with the groups abruptly ended in 2010. Thanks to Louisiana's massive budget cuts to several state programs, including art and education, the Louisiana Folklife Program was terminated, making it now even harder for not just the Isleños but all Louisiana cultures—whether the Vietnamese immigrants in New Orleans East, the Native Americans or the Cajuns—to preserve what is slipping away on a daily basis.

Even now, the Isleños remain mostly unknown, even in Louisiana, even in New Orleans. Yet they have affected the history of southeast Louisiana

and that of the state as a whole. The Spanish period itself often pales in comparison to the French legacy that usually defines New Orleans and the surrounding territory, but the Canary Islanders have left their mark. In their early years as farmers, they supported the growth of New Orleans as it transformed into one of the most influential cities and the most important port in America. As new citizens in a new country, they defended the United States against the invading British and contributed to a victory that is still commemorated today. As trappers and fishermen, they supplied the city's restaurants and markets with the fowl and fish that made New Orleans cuisine so famous. Even now, they stand as the defenders of a receding coast. Invisible but integral, the Isleños are still there.

Isolation is ultimately the saving grace and kiss of death to the Isleños. Since 1778, isolation has nurtured, protected and insulated their culture, allowed it to thrive and remain strong in containment. Without drastic external influences, the Isleños lived fundamentally the same as their ancestors had until the mid-twentieth century. Newspapers, travel accounts and personal stories reflect this lack of change. But after the modern world and all of its conveniences and allure seeped into the fabric of their daily lives, isolation became a vice. Most older Isleños were stuck rooted in their ways, but the young broke tradition, left the parish and fractured Isleño unity. Every day the land shrinks a little more; with every storm the Isleño population dwindles.

In August 2010, as headlines involving the oil spill stretched across the page, the *Times-Picayune* ran a series written by Bob Marshall on the history of the Isleños in Delacroix. In the articles, Marshall recorded his interviews with Isleño locals, who stressed the disappearance of their culture as the younger generations turn away from tradition and as the marsh grass melts into water. The Isleños, of course, remain elsewhere in St. Bernard and southeast Louisiana, but the residents there in Delacroix Island promote the area as the center of the Isleño population where trawling and shrimping held on for decades. Yet in the last installment of the series, Marshall wrote that "today, fewer than 15 families live in the community full time. Most new construction after the storm was for fishing camps. Commercial crabbing is still viable, but most crabbers commute, just like the sportsmen, the 'chivos' they once ridiculed as clueless outsiders."[9]

The Isleños, in many ways, cannot coexist with the modern world—their lifestyle is something from the past, and young Isleños have to choose between a life like their fathers' backbreaking work in the water and sun and one of

endless opportunity outside the area. A schism has developed, separating the older generation from the largely disinterested youth. There is little compromise between the two forces of modernity and Isleño tradition, and because of that the Isleños are a threatened species. Noble efforts are being made to capture Isleño history, but without the support of the next generation, very little will last.

Despite the eagerness and the spirit of the people, the battle to save and maintain Isleño culture remains bleak. In the two hundred years since their arrival in this marsh, the Isleños have repeatedly proven that they are up for a challenge, and the environment that they face in the twenty-first century may be their most difficult ordeal yet. Even before the storms of 2005, traditions had dissolved with every generation. Modern families rarely speak the Isleño dialect of the Spanish language, if they speak Spanish at all, and like Galveztown and Baratatia before it, St. Bernard faces the breakdown of its Isleño heritage. As the Isleños continue to leave the coast in unprecedented numbers, the strength of the community, once unbreakable, now wanes. For those die-hards who remain, the loss of community, the ruin of marshlands, the mussel growth on the oysters and now the oil spill impair the fishing industry, and many former fishermen now work at the oil and natural gas refineries spread along the Greater New Orleans Area. The storms of 2005 destroyed the fishing camps along Lake Borgne. *Décimas* singers such as local legend Irvan Perez used to be a defining part of Isleño culture, but as the older generation ages, key aspects of the group's identity fade into memory. Unwilling to move away from the land and tightknit community that have defined their culture, and unable to preserve their culture in totality if they did move, the Isleños are trapped by their own doing and the doing of time and progression.

To escape the Catch-22 and save their existence for the next generation, the Isleños need to learn to utilize the benefits of modern historical and cultural preservation besides simply living it. For most Isleños, this process of preservation and cultural retention is fancy terminology for what they would do anyway—pass on their ways to their children. Theirs is very much an oral tradition. However, the future of the Isleños demands an active effort to write down their stories, document their knowledge and educate children in the area of Isleño history beyond a photo caption or a single line in a single paragraph of a seventh-grade history textbook. Because of World War II, Betsy, Katrina, the oil spill and the difficulty of returning, they can no longer exist as they always have. In addition to teaching their children, they need

to embrace modern methods of preservation. They simply will not last past these new, less unified and more geographically distant generations. The establishment of organizations in Baton Rouge and St. Bernard is a vital first step, but the next generation needs to learn what the Isleños stand for and the blood-bound community in which they are a part. Unfortunately, nothing can turn back the clock, undo the damage that has already been done and regain what pieces of the puzzle have already been lost. With hard work, those remaining cultural leaders can record their experiences to save what is left.

The Isleños are everywhere in the South and in Louisiana, whether they recognize their heritage or not. As John Hickey put it:

> *We had a Spanish period in Louisiana which not too many people are aware of. A number of the Spanish names have Italian-type soundings to them or can. And we've had several people who said, "I always thought I was Italian" or "You know it's strange, I never thought about it before, but my grandmother spoke Spanish." And I tell people when I speak to groups that even though you're a Broussard or an Hebert or a Thibodaux, your great-grandmother or your grandmother probably was a Hernandez or a Suarez or a Falcon. In other words, you've got Canary Island ancestors.*

Thousands of Canary Island descendants have become so Americanized that they are no longer part of their traditional community and culture.

For those hundreds of Isleños who do remain and do remember, they face a new dawn and a new phase in their history here that threatens change and the uncertainty of an unknown future. Every hurricane season, every wave that erodes the coast of their water-permeated land and the billions of possibilities that no one can ever fathom will inevitably shape their future into something different than what they have known for nearly two hundred years. Constant but often unnoticeable changes alter their lives almost daily. But the Isleños remain on the water's edge nevertheless, with the sunlight turning the crests of their waves diamond white and the grass of their fields green and gold, and like those before them who took a first step from the dock and into Louisiana's marsh, they face a new horizon.

For more information on Isleños organizations, please contact:

Los Isleños Heritage and Cultural Society
http://www.losislenos.org

Canary Islanders Heritage Society of Louisiana
http://www.canaryislanders.org

Canary Islands Descendants Association
600 St. Bernard Parkway
Braithwaite, LA 70040

NOTES

CHAPTER 1

Unfortunately, the Guanches are still very much a mystery. Alfred Crosby's engaging article entitled "An Ecohistory of the Canary Islands: A Precursor of European Colonialization in the New World and Australasia" was invaluable to understanding the process of Spanish conquest; however, the piece, like so many others on Guanches history and origins, is outdated. "Blood Groups and the Affinities of the Canary Islands" by D.F. Roberts, M. Evans, E.W. Ikin and A.E. Mourant was a huge step toward scientifically pegging the origins of these mysterious mountainfolk, but in the nearly fifty years that have passed, too few researchers have expounded on what they started.

As for the Spanish period in Louisiana, despite recent scholarship in Louisiana history, the Spanish period is often overlooked when compared to the more well-known French dominion. Existing literature often deals only indirectly with the Spanish transformations, and the lack of debate in this field shows the necessity of further research on Louisiana's Spanish period. Current scholarship too often focuses exclusively on major figures and events, such as Bernardo de Galvez in John Caughey's *Bernardo de Galvez in Louisiana* and the French revolt in Carl A. Brasseaux's "Confusion, Conflict, and Currency: An Introduction to the Rebellion of 1768." If these works mention the Isleños at all, it is often only in passing. Even in his laudable biography of Galvez, Caughey focuses more intently on the governor's numerous other achievements. New collections need to be explored and new

questions asked, and like the Isleños, the Spanish period in Louisiana as a whole needs to be better analyzed and dissected by Louisiana historians.

1. Roberts, Evans, Ikin and Mourant, "Blood Groups and the Affinities of the Canary Islanders," 520.
2. Crosby, "An Ecohistory of the Canary Islands," 219.
3. Ibid., 220.
4. Ibid.
5. Ibid.
6. Ibid., 226.
7. Ibid., 230.
8. Ibid., 229.
9. Din, *Canary Islanders of Louisiana*, 7.
10. Ibid., 16–17.
11. Ibid., 19–20.
12. Ibid., 18.
13. Ibid., 21.
14. Ibid., 28–29.
15. Ibid., 31.
16. Ibid., 32.
17. Ibid., 65.
18. Ibid., 67, 75.
19. Ibid., 56.
20. Arthur, *Old Families of Louisiana*, 396.
21. Din, *Canary Islanders of Louisiana*, 57.

CHAPTER 2

My reliance on Din's research in this chapter on Isleño history and the following was a judgment call made by recognizing the potential audience and general purpose of the book. More critical, academic work in the future should incorporate primary sources from the Archivo General de Indias in Seville and the Louisiana State Museum archives. Din's book, while wonderful at its publication, has left many questions unanswered by standing as a survey of the Isleños and not as a detailed analysis of key moments in their history. Future work in the field should strive to answer these questions and expand the academia-intended literature on the Isleños.

1. Din, *Canary Islanders of Louisiana*, 91.
2. Ibid., 105.
3. Ibid., 118–121.
4. Ibid., 119–120.
5. Ibid., 120.
6. Ibid., 94.
7. Ibid., 128.
8. Quoted in Din, *Canary Islanders of Louisiana*, 126.

CHAPTER 3

1. Padrón, Justo Jorge, "Canto Decimoquinto, Los Guanches / Fifteenth Canto, The Guanches," *Poesía, Arte y Crítica* (Sirena: Johns Hopkins University Press, 2007), 140–51.
2. Din, *Canary Islanders of Louisiana*, 145.
3. Ibid., 149.
4. Gowland, "Delacroix Isleños and the Trappers' War," 424.
5. Din, *Canary Islanders of Louisiana*, 149.
6. Ibid., 427.
7. Ibid., 435.
8. Ibid.
9. Ibid.
10. Barry, *Rising Tide*, 193.
11. Ibid., 163.
12. Ibid., 164-165.
13. Ibid., 165.
14. Din, *Canary Islanders of Louisiana*, 151. Din details an incident during Prohibition in which Deputy Sheriffs Joseph Estopinal and August Esteves, who were manning a liquor checkpoint, were shot and killed. J. Claude Meraux was indicted, but thanks to Perez's maneuverings, he was not convicted and was shortly released.
15. Ibid., 193.
16. Department of the Army, New Orleans District, Corps of Engineers, *Hurricane Betsy: After-Action Report*, 1.
17. "'Closing' the Mississippi River Gulf Outlet: Environmental and Economic Considerations." Coastal Wetlands Planning, Protection and

Restoration Act. Web. 23 Oct. 2010. http://www.lacoast.gov/new/Data/Reports/ITS/MRGO.pdf.

18. Din, *Canary Islanders of Louisiana*, 198.

CHAPTER 4

1. Bill Hyland, interview with the author, St. Bernard, Louisiana, March 21, 2009.
2. Coalition to Restore Coastal Louisiana. "Land Loss." http://www.crcl.org/theissue.html.
3. Office of Coastal Protection and Restoration | Governor of Louisiana. "Land Loss." http://www.coastal.la.gov/index.cfm?md=pagebuilder&tmp=home&pid=72.
4. America's Wetland Foundation. "Campaign Overview." http://www.americaswetland.com/custompage.cfm?pageid=2&cid=5.
5. Office of Coastal Protection and Restoration | Governor of Louisiana. http://coastal.louisiana.gov.
6. Glynn Boyd, "Abita Beer Brews New Beer to Help Save Louisiana's Coast and to Benefit Those Impacted by the Oil Spill," WGNO, ABC-26, June 23, 2010. http://www.abc26.com/news/local/wgno-news-abita-fundraiser,0,4452194.story.
7. "Louisiana Oyster Shells Could Prevent Coastal Erosion," WDSU.com, November 19, 2008. http://www.wdsu.com/news/18019125/detail.html.
8. Ibid.

CHAPTER 5

Researchers will inevitably encounter a problem of finding source material when working on Isleño culture. The Isleños, by the nature of their isolation, have depended on oral tradition to pass on their stories and folk customs. Little was written down before the initiative of the social organizations. As a result, I relied on interviews with cultural leaders as much as possible for this chapter to document their traditions and customs. So much has already been lost in the recent decades, and cultural researchers, whether historians or anthropologists, should explore the oral histories in St. Bernard's Delacroix Island for more information on the subject.

1. Lestrade, "Last of the Louisiana Décimas," 448.
2. Patricia Sullivan, "Irván Pérez, 85; Singer of Décimas Preserved Isleños Culture, Dialect," January 17, 2008. http://www.washingtonpost.com/wp-dyn/content/article/2008/01/16/AR2008011603882.html.
3. Lestrade, "Last of the Louisiana Décimas," 448–49.
4. Lipski, *Language of the Isleños*, vii.
5. Louisiana Folklife Center at Northwestern State University, "Artist Biographies: Charles R. Robin Jr.: Shrimper and Miniature Boat Maker." http://louisianafolklife.nsula.edu/artist-biographies/profiles/186.
6. Molly Reid, "See Isleños Boat-Builder at New Orleans Jazz Fest," *Times-Picayune*, April 25, 2010. http://www.nola.com/homegarden/index.ssf/2010/04/islenos_boat-builder_keeps_ali.html.

Chapter 6

1. *Times-Picayune*, "Hurricane Prompts School Closures," August 27, 2005. http://www.nola.com/katrina/index.ssf/2005/08/hurricane_prompts_school_closures.html.
2. Ibid., "St. Bernard Shelters Busy," August 28, 2005. http://www.nola.com/katrina/index.ssf/2005/08/st_bernard_shelters_busy.html.
3. Bruce Nolan, "Remembering Katrina," August 29, 2006. http://www.nola.com/katrina/index.ssf/2006/08/remembering_katrina.html.
4. Richard D. Knabb, Jamie R. Rhome and Daniel P. Brown, "Tropical Cyclone Report: Hurricane Katrina," National Hurricane Center. http://www.nhc.noaa.gov/pdf/TCR-AL122005_Katrina.pdf.
5. *Times-Picayune*, "St. Bernard Flooding Update," August 29, 2005. http://www.nola.com/katrina/index.ssf/2005/08/st_bernard_flooding_update.html.
6. Ibid., "St. Bernard Rescue," August 31, 2005. http://www.nola.com/katrina/index.ssf/2005/08/st_bernard_rescue.html.
7. Ibid., "100 Said Dead in Chalmette," September 1, 2005. http://www.nola.com/katrina/index.ssf/2005/09/100_said_dead_in_chalmette.html.
8. Ibid., "Urgent Plea from St. Bernard Parish," September 1, 2005. http://www.nola.com/katrina/index.ssf/2005/09/urgent_plea_from_st_bernard_parish.html.
9. Marianne Hirsh, "Past Lives: Postmemories in Exile," *Poetics Today* 17, no. 4 (Winter 1996): 662.

CHAPTER 7

1. Paul Rioux and Chris Kirkham, "Burning Oil Rig Sinks into Gulf of Mexico, Coast Guard says," *Times-Picayune*, April 22, 2010. http://www.nola.com/news/index.ssf/2010/04/burning_oil_rig_sinks.html.

2. Ibid., "Oil Rig Explosion Could Become One of Deadliest Industry Disasters in Gulf," *Times-Picayune*, April 23, 2010. http://www.nola.com/news/index.ssf/2010/04/oil_rig_explosion_could_become.html.

3. *Times-Picayune*, "Oil Leak from Gulf Rig Explosion No Danger to Shoreline at This Point, Coast Guard chief says," April 26, 2010. http://www.nola.com/news/index.ssf/2010/04/coast_guard_chief_no_onshore_i.html.

4. Bob Warren, "Boom, Trawlers Deployed in St. Bernard Parish to Combat Oil Spill," *Times-Picayune*, May 21, 2010. http://www.nola.com/news/gulf-oil-spill/index.ssf/2010/05/boom_trawlers_deployed_in_st_b.html.

5. Chris Kirkham, "St. Bernard Parish's Spending of BP Oil Spill Money Detailed," *Times-Picayune*, June 24, 2010. http://www.nola.com/news/gulf-oil-spill/index.ssf/2010/06/st_bernard_parish_spending_of.html.

6. *Times-Picayune*, "State Reopens Fishing Area in St. Bernard Parish," June 15, 2010. http://www.nola.com/news/gulf-oil-spill/index.ssf/2010/06/state_reopens_fishing_area_in.html.

7. Bettina Boxall, "Dead Coral Found Near BP Well Site in Gulf of Mexico," *Los Angeles Times*, November 6, 2010. http://www.latimes.com/news/nationworld/nation/la-na-dead-coral-20101106,0,5708586.story.

8. John Membrino, "Scientists Find Dead Coral Near Site of BP Oil Spill," AOL News, November 6, 2010. http://www.aolnews.com/nation/article/scientists-find-dead-coral-near-site-of-bp-oil-spill/19705819?icid=maing%7Cmain5%7C1%7Clink2%7C23903.

9. Bob Marshall, "A Paradise Lost: Living in a Graveyard," *Times-Picayune*, August 4, 2010.

Selected Bibliography

Arthur, Stanley Clisby. *Old Families of Louisiana*. Gretna, LA: Firebird Press, 2009.

Barry, John M. *Rising Tide: The Great Mississippi Flood of 1927 and How It Changed America*. New York: Simon & Schuster, 1998.

Beazley, C. Raymond. "The French Conquest of the Canaries in 1402–6, and the Authority for the Same." *Geographical Journal* 25, no. 1 (January 1905): 77–81.

Brasseaux, Carl A. "Confusion, Conflict, and Currency: An Introduction to the Rebellion of 1768." *Louisiana History: The Journal of the Louisiana Historical Association* 18, no. 2 (Spring 1977): 161–69.

Caughey, John. *Bernardo de Galvez in Louisiana, 1776–1784*. Gretna, LA: Firebird Press, 1972.

Clark, Emily. *Masterless Mistresses: The New Orleans Ursulines and the Development of a New World Society, 1727–1834*. Chapel Hill: University of North Carolina Press, 2007.

Clark, John. *New Orleans 1718–1812: An Economic History*. Gretna, LA: Pelican Publishing, 1982.

Conrad, Glenn R., and University of Southwestern Louisiana Center for Louisiana Studies. *The French Experience in Louisiana.* Lafayette: University of Southwestern Louisiana, 1995.

Cook, Alice Carter. "The Aborigines of the Canary Islands." *American Anthropologist* 2, no. 3. (September 1900): 451–93.

Crosby, Alfred W. "An Ecohistory of the Canary Islands: A Precursor of European Colonialization in the New World and Australasia." *Environmental Review* 8, no. 3 (Autumn 1984): 215–35.

Dawdy, Shannon Lee. *Building the Devil's Empire: French Colonial New Orleans.* Chicago, IL: University Of Chicago Press, 2009.

De Macedo, J.J. da Costa. "Ethnographical Remarks on the Original Languages of the Inhabitants of the Canary Isles." *Journal of the Royal Geographical Society of London* 11 (1841): 171–83.

Department of the Army, New Orleans District, Corps of Engineers. *Hurricane Betsy: After-Action Report.* New Orleans, LA: Army Corps of Engineers, 1966.

De Pedro, José Montero. *The Spanish in New Orleans and Louisiana.* Gretna, LA: Pelican Publishing, 2000.

Din, Gilbert C. "The Canary Islander Settlements of Spanish Louisiana: An Overview." *Louisiana History: The Journal of the Louisiana Historical Association* 27, no. 4 (Autumn 1986): 353–73.

———. *The Canary Islanders of Louisiana.* Baton Rouge: Louisiana State University Press, 1988.

———. "'For Defense of Country and the Glory of Arms': Army Officers in Spanish Louisiana, 1766–1803." *Louisiana History: The Journal of the Louisiana Historical Association* 43, no. 1 (Winter 2002): 5–40.

———. "Proposals and Plans for Colonization in Spanish Louisiana, 1787–1790." *Louisiana History: The Journal of the Louisiana Historical Association* 11, no. 3 (Summer 1970): 197–213.

Gowland, Bryan M. "The Delacroix Isleños and the Trappers' War in St. Bernard Parish." *Louisiana History: The Journal of the Louisiana Historical Association* 44, no. 4 (Autumn 2003): 411–41.

Holmes, Jack D.L. "Vidal and Zoning in Spanish New Orleans, 1797." *Louisiana History: The Journal of the Louisiana Historical Association* 14, no. 3 (Summer 1973): 270–82.

Jeansonne, Glen. *Leander Perez: Boss of the Delta.* Jackson: University Press of Mississippi, 2006.

Lestrade, Patricia Manning. "The Last of the Louisiana Décimas." *Hispania* 87, no. 3 (September 2004): 447–52.

Lipski, John M. *The Language of the Isleños: Vestigial Spanish in Louisiana.* 1st ed. Baton Rouge: Louisiana State University Press, 1990.

Los Isleños Heritage & Cultural Society. *Los Isleños Cookbook: Canary Island Recipes.* 1st ed. Gretna, LA: Pelican Publishing, 2000.

Merediz, Eyda M. *Refracted Images: The Canary Islands Through a New World Lens, Transatlantic Readings.* Arizona Center for Medieval and Renaissance Texts and Studies, 2004.

Moore, John Preston. "Antonio de Ulloa: A Profile of the First Spanish Governor of Louisiana." *Louisiana History: The Journal of the Louisiana Historical Association* 8, no. 3 (Summer 1967): 189–218.

Parsons, James J. "The Migration of Canary Islanders to the Americas: An Unbroken Current Since Columbus." *Americas* 39, no. 4 (April 1983): 447–81.

Roberts, D.F., M. Evans, E.W. Ikin and A.E. Mourant. "Blood Groups and the Affinities of the Canary Islanders." *Man* 1, no. 4. New Series (December 1966): 512–25.

Spear, Jennifer M. *Race, Sex, and Social Order in Early New Orleans.* Baltimore, MD: Johns Hopkins University Press, 2009.

Steckley, George F. "The Wine Economy of Tenerife in the Seventeenth Century: Anglo-Spanish Partnership in a Luxury Trade." *Economic History Review* 33, no. 3. New Series (August 1980): 335–50.

Stevens-Arroyo, Anthony M. "The Inter-Atlantic Paradigm: The Failure of Spanish Medieval Colonization of the Canary and Caribbean Islands." *Comparative Studies in Society and History* 35, no. 3 (July 1993): 515–43.

Sublette, Ned. *The World that Made New Orleans: From Spanish Silver to Congo Square.* Chicago, IL: Lawrence Hill Books, 2009.

Tinajero, Pablo Tornero, and Paul E. Hoffman. "Canarian Immigration to America: The Civil-Military Expedition to Louisiana of 1777–1779." *Louisiana History: The Journal of the Louisiana Historical Association* 21, no. 4 (Autumn 1980): 377–86.

Whitaker, Arthur Preston. *The Mississippi Question 1795–1803: A Study in Trade, Politics, and Diplomacy.* New York: D. Appleton-Century Company, 1934.

About the Author

S amantha Perez is a resident of St. Bernard Parish and active in preserving her own Isleño roots. In 2005, as a senior in high school, she lost her home to Hurricane Katrina and wrote a series of journalism articles on her personal experiences with the storm and the gradual emotional and physical recovery process. In 2006, her work on the storm earned the Professor Mel Williams Award for Writing Excellence through the Scholastic Press Forum, the Suburban Newspapers of America's Award for Best Feature and the honor of Louisiana State Senate Resolution No. 127, which was presented in recognition of her journalism work following Katrina.

As a junior at Southeastern Louisiana University in Hammond, she and communications major Joshua Robin created an hour-long documentary called "Louisiana's Lost Treasure: The Isleños," which they presented as part of Fanfare, Southeastern Louisiana University's celebration of the arts. The success of the documentary led to presentations at academic conferences, including the Louisiana Historical Association Convention and the Gulf South History and Humanities Conference. In 2010, she graduated with degrees in history and honors English and minors in creative writing and gender studies from Southeastern. She is currently pursuing graduate study at Tulane University, where she will earn her PhD in late medieval/early modern European history.

Visit us at
www.historypress.net